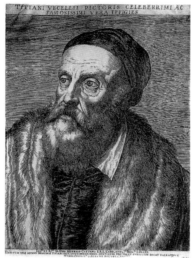

TITIANI VECELLII PICTORIS CELEBERRIMI AC
FAMOSISSIMI VERA EFFIGIES

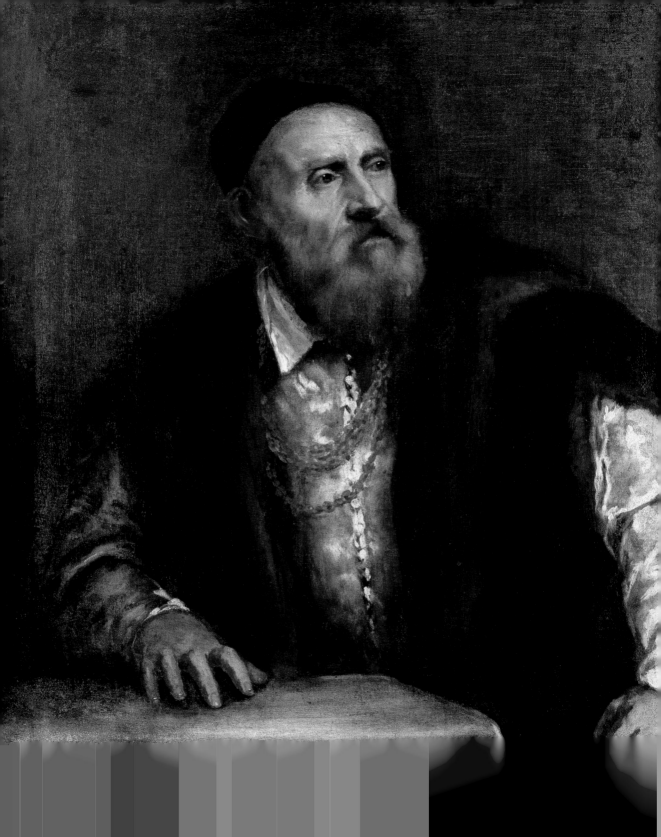

Ian G. Kennedy

TITIAN

circa 1490–1576

TASCHEN

KÖLN LONDON LOS ANGELES MADRID PARIS TOKYO

FRONT COVER:
Venus with a Mirror, c. 1560
Oil on canvas, 106.8 x 136 cm
Washington (DC), National Gallery of Art

BACK COVER:
Self-portrait, c. 1546/47
Oil on canvas, 96 x 75 cm
Berlin, Staatliche Museen zu Berlin – Preussischer
Kulturbesitz, Gemäldegalerie

PAGE 1:
Agostino Carracci
Portrait of Titian
Engraving

PAGE 2:
Self-portrait, c. 1546/47
Oil on canvas, 96 x 75 cm
Berlin, Staatliche Museen zu Berlin – Preussischer
Kulturbesitz, Gemäldegalerie

To stay informed about upcoming TASCHEN titles, please request
our magazine at www.taschen.com/magazine or write to
TASCHEN America, 6671 Sunset Boulevard, Suite 1508, USA-Los Angeles, CA 90028,
contact-us@taschen.com, Fax: +1-323-463.4442.
We will be happy to send you a free copy of our magazine
which is filled with information about all of our books.

© 2006 TASCHEN GmbH
Hohenzollernring 53, D–50672 Köln
www.taschen.com

Project coordination: Petra Lamers-Schütze
Layout and editorial coordination: Daniela Kumor, Cologne
Editing: Karen McDermott
Cover design: Claudia Frey, Cologne

Printed in Germany
ISBN 3-8228-4912-x

Contents

6

Titian in Venice: The Early Years

14

Rise to Prominence: Madonnas and Beautiful Women

30

Fame and Wider Horizons: The *Assumption of the Virgin,*
the *Pesaro Madonna* and the Ferrara *Bacchanals*

40

The 1530s: New Ideas and New Patrons

52

Papal Patronage and Give and Take with Rome

68

Working for the Hapsburgs: Charles V and Philip II

78

"Chromatic Alchemy": The Late Works

94

Chronology

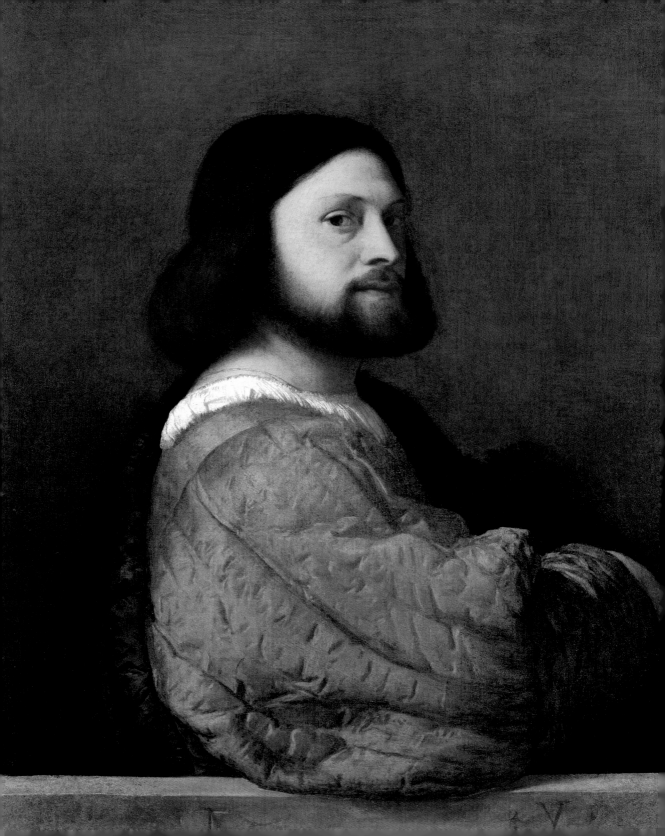

Titian in Venice: The Early Years

No documents record the birth of Titian, but he was born into the minor gentry probably around 1490 in Pieve di Cadore, a small town in the upper Piave valley in the Dolomites. His grandfather had been a leading figure in the community and his father, Gregorio, distinguished himself during the abortive invasion of Italy by imperial troops under the Emperor Maximilian in 1508. Thus the greatest Venetian artist of all time was by birth a mountain man, and he never lost touch with his birthplace, where his family had a prosperous lumber business. Titian arrived in Venice at the age of somewhere between ten and twelve. He got his start in the workshop of Sebastiano Zuccato, a minor artist, then transferred to the studio of Gentile Bellini and subsequently to that of his more famous brother, Giovanni. The documentary realism of Gentile's detailed panoramas of Venetian life would have been useful in learning the rudiments of portraiture and an introduction to working on a large scale. However, it was Giovanni who had brought Venetian painting to the front rank, exploiting the relatively newly developed technique of oil painting to create a more potent sense of reality through atmospheric unity, and elevating the role of light and color to a sublime and expressive vehicle for emotional content. Titian was to remain much in his debt, but he soon gravitated towards Giorgione who, more than the much older Bellini, represented the cutting edge of contemporary Venetian art. Giorgione had combined the coloristic power of Bellini with Leonardo's elemental tonal realism, creating an elusive, less static world vulnerable to change. Titian was to absorb his style very thoroughly but possessed a more robust artistic personality, which after the death of Giorgione in 1510 gave him the necessary leadership potential to become Bellini's successor as *caposcuola* of the Venetian High Renaissance, carrying the torch of Venetian luminism and color through the next generation. In Titian's work, the veil of reticence and mystery that clings to Giorgione is now lifted, and humanity is confronted more directly and with a psychological clarity grounded in everyday experience. This aspect of his work is often taken for granted, and a principal aim of this short account of Titian's life and work is to set it out more clearly.

Titian's earliest securely dateable works, from c. 1509, were frescoes on the outer wall of the Fondaco dei Tedeschi, a trading center built for Venice's German community, and on whose façade Giorgione, too, had worked. Only fragments of both artists' work survive. Giorgione is also close at hand in one of

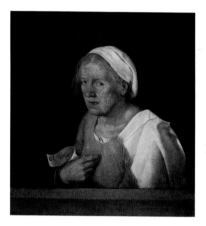

Giorgione
Old Woman, c. 1509
Oil on canvas, 96 x 88 cm
Venice, Galleria dell'Accademia

The sitter must have been beautiful when young, so this painting carries a warning that all beauty must fade.

Man with the Blue Sleeve, c. 1510
Oil on canvas, 84.6 x 69.5 cm
London, The National Gallery

The biographer Giorgio Vasari, in his *Life of Titian*, describes a similar portrait which he says could easily have been mistaken for a Giorgione if Titian had not signed it.

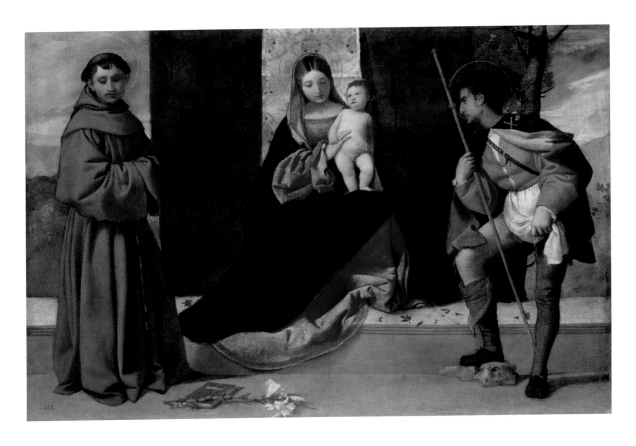

Madonna and Child with SS Anthony of Padua and Roch, c. 1511
Oil on canvas, 92 x 133 cm
Madrid, Museo Nacional del Prado

Titian's earliest works on canvas, the *Man with the Blue Sleeve* (p. 6). In its gripping tonal palpability and attention to detail, such as the stitching in the satin, it has much in common with Giorgione's late portraits, for example his *Old Woman* (p. 7). But Titian, somewhat competitively, carries Giorgione's realism a step further in the way the sleeve billows out and invades our space, extending the boundaries of *Giorgionismo* in a burst of hyperrealism. The sitter's expression is arrogant, typical of the male dandy or clothes-horse, but in another early portrait, the so-called *Schiavona* (the *Dalmatian Woman*; p. 9, below), the lady's physical presence is boosted by her more sympathetic personality. Titian's continuing interest in texture is shown by the dense, woolen fabric of her dress, but her frank stare pinning the spectator down before the canvas is new. Her expression is reflective and benign and may be a comment on transience. The sitter's profile in the carved relief has the character of a memorial, while in the main image she confronts us with good-humored resignation, acknowledging to herself and to us the inevitability of death.

One of Titian's earliest religious paintings, the *Madonna and Child with SS Anthony of Padua and Roch* (p. 8) was until fairly recently attributed to Giorgione, and the Virgin with her delicate, oval face and crisp folds of red drapery defined by shadow descends from the more remote and queenly Virgin of Giorgione's only altarpiece, the *Castelfranco Madonna* (p. 9, above). Typical of Titian's greater directness is the way the magnificent isolation of Giorgione's figures has now disappeared and everyone communicates better. St Roch – traditionally in-

voked against the plague – leans benignly towards the Christ Child, while the Virgin pays her son more attention, supporting him with both hands. Titian's Christ is less spiritual than Giorgione's, but more alert: he looks towards St Anthony, who turns diffidently away as if unfit to contemplate the divine presence. Thus the saint's well-known modesty, tying him down to the level of ordinary humanity, draws us in as part of the family.

Giorgione's fame also spread through smaller works for private collectors, some of them landscapes with figures, and in this genre, too, he influenced his younger colleague. This brings us to the most Giorgionesque of all Titians, the *Concert Champêtre* (pp. 10–11), in the past always given to Giorgione and at times the subject of disagreement even today. The Titian attribution is nevertheless justified by the very specifically descriptive body language, even if the meaning of the picture is still elusive. The richly dressed lute player may be inspired by Sannazaro's pastoral poem *Arcadia*, where a sophisticated lovelorn townsman takes to the woods to forget his troubles. He appears to be giving the shepherd instruction in how to play the lute and is about to strike a chord. The shepherd, having turned abruptly to listen and to look, ignores the nymph with the flute, who holds her instrument in suspended animation as she awaits the shepherd's reaction to his mentor. The easy-to-play flute is the instrument of Arcadian simplicity, the harder-to-play lute that of the sophisticated courtier. Thus the shepherd may be receiving guidance in the ways of a wider world either musical or amatory, since music was the food of love long before Shakespeare. The profile of the nymph on the left shows traces of anxiety as she pours water from a glass jug into the basin of the fountain. As the waters commingle, perhaps she reflects on the perils of exposing Arcadia to courtly values, her separation from the others placing her in the role of commentator on the music lesson.

The only precisely documented works of Titian's early period are his frescoes in the Scuola del Santo in Padua of 1511, representing the *Miracles of St Anthony of Padua*. After the War of the League of Cambrai of 1509, when the Hapsburgs, the Valois, the Pope, and rival North Italian principalities had gone to war with Venice to block her territorial ambitions on the mainland, Padua, a Venetian dependency, fell to imperial troops. The city rapidly returned to Venetian hegemony, however, which – despite a certain level of dissidence – may have influenced the choice of a rising Venetian artist. The theme of the murals, alluding to forgiveness and reconciliation, is also appropriate to the circumstances of the times. The most dramatic of the frescoes is the *Miracle of the Jealous Husband* (p. 12), the most mature the *Miracle of the Speaking Babe* (p. 13). In the latter, Titian has fine-tuned the reactions of his cast with a clarity and a matter-of-fact realism that would become two of the cornerstones of his greatness. The setting is medieval Ferrara, where a Marquis of the house of Este suspects his child to have been fathered by another. Despite the wife's protestation of innocence, the judge on the case is unable to reach a verdict. At St Anthony's instigation, however, and though too young to talk, the child declares the Marquis to be his true father. Titian has been broadminded enough to take in Giotto's frescoes of three centuries earlier in the nearby Arena Chapel. Thus the kneeling friar holding the child is based on Giotto's Christ in the *Washing of the Feet*, and the monolithic bulk of the accused wife to the right is equally Giottesque. The main group, comprising the Franciscan holding the child, St Anthony and the husband and wife, are set in a shallow semicircle as they listen to what the child says. The child appears to have spoken, and the audience is absorbing the new evidence. The wife remains patient, dignified and self-contained in the knowledge that she

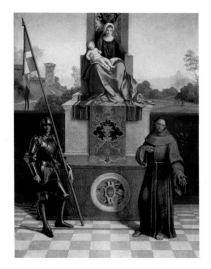

Giorgione
Castelfranco Madonna, c. 1503
Oil on panel, 200 x 152 cm
Castelfranco Veneto, Cathedral

A masterpiece of sublime and remote grandeur, this altarpiece has been unfairly criticized in recent times as timid and provincial and has even been attributed to another artist, Domenico Mancini.

La Schiavona, c. 1510–1512
Oil on canvas, 119.2 x 100.4 cm
London, The National Gallery

The inclusion of the sitter's portrait carved in stone may refer to the much discussed issue of the relative merits of painting and sculpture.

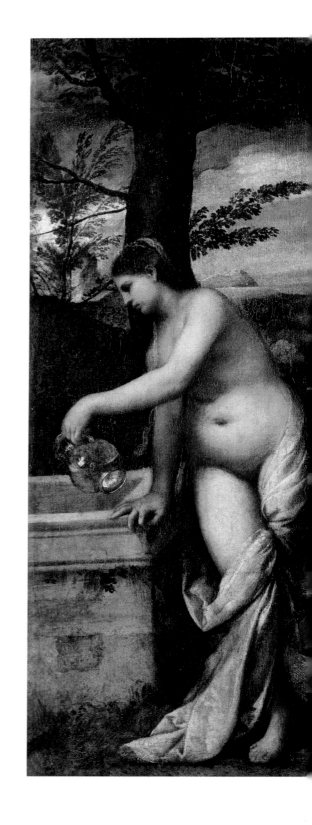

Concert Champêtre, c. 1511
Oil on canvas, 110 x 138 cm
Paris, Musée du Louvre

Attributed to Giorgione until fairly recently, this
painting was central to the dictum of the late
19th-century aesthete and critic Walter Pater,
that art "aspires to the condition of music."

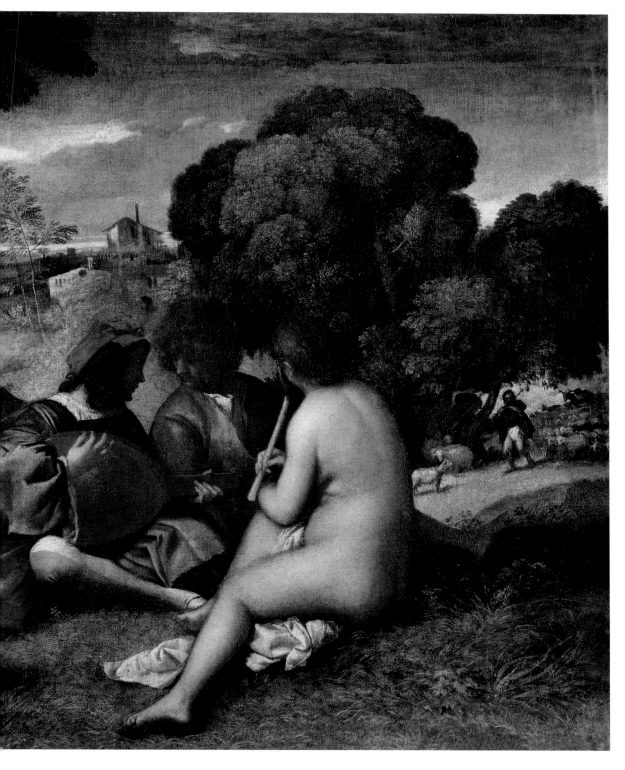

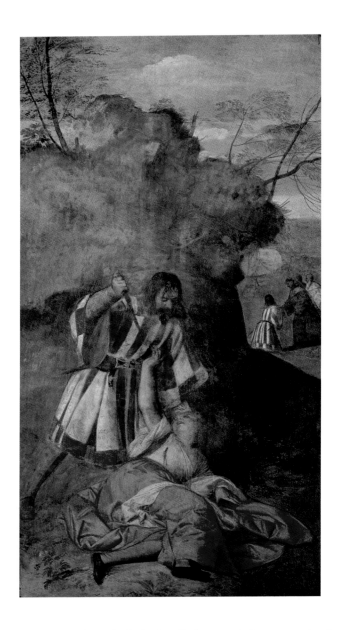

Miracle of the Jealous Husband, 1511
Fresco, 320 x 185 cm
Padua, Scuola del Santo

The husband fatally wounds his allegedly un-
faithful wife, but she is revived by St Anthony,
who is shown in the background assuring the
penitent husband of her innocence.

has been vindicated. The husband's downward glance concedes the child is right
while the man at his shoulder, possibly the judge, smiles in satisfaction at the
outcome and in wonder at the miracle. The saint's expression is well handled, as
if to say, "Here's your proof." To this day St Anthony is revered as a miraculous
agent of healing in the Basilica in Padua, and Titian portrays him in the manner
of a celebrated doctor, combining compassion with the practiced authority of
the successful and busy professional. The aggressive and extravagantly dressed
youth advancing from the left is possibly a member of the Compagnia della Cal-
za, an aristocratic Venetian fraternity. It has been suggested he may be the suspec-
ted adulterer brought up under guard by the spearman to hear the child's verdict.

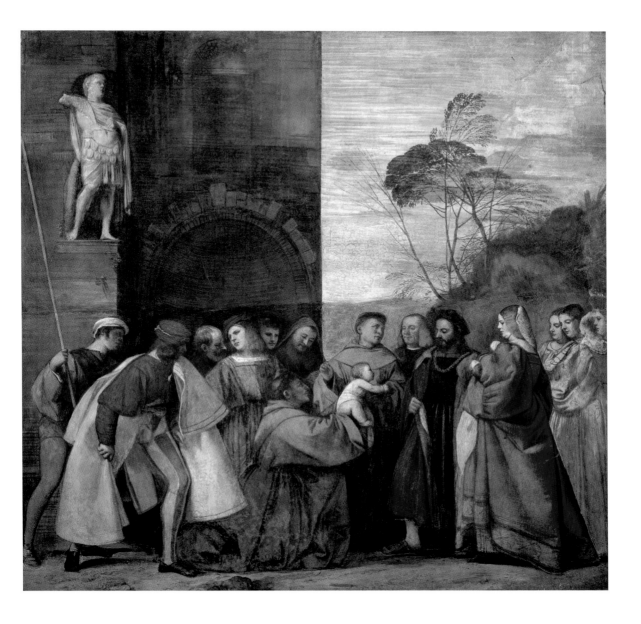

Miracle of the Speaking Babe, 1511
Fresco, 320 x 315 cm
Padua, Scuola del Santo

A problem yet to be resolved is why the
Miracle of the Speaking Babe, the most
accomplished of the three frescoes, is assumed
from the documents to have been painted first,
while the least accomplished, the *Miracle of
the Healed Foot*, is thought to have been
painted last.

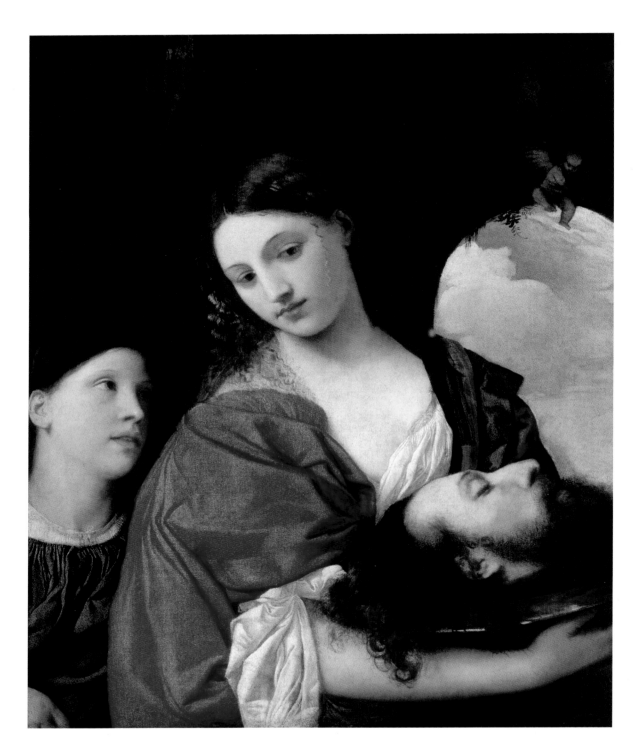

Rise to Prominence: Madonnas and Beautiful Women

After the death of Giorgione in 1510 and Sebastiano del Piombo's departure to Rome the following year, Titian was left with no serious Venetian rival apart from the aging Bellini. His breezy confidence at this time declares itself with a flourish of trumpets in his *St Mark Altar* (p. 15) in Santa Maria della Salute. As in the *Madonna and Child with SS Anthony of Padua and Roch* (p. 8), Titian's figures proclaim a new, demonstrative clarity. Space is restricted in order to magnify their physical presence, and the strong local colors are just as important in the definition of space as the perspective and the disposition of the figures within it. The subject matter relates to the plague that struck virulently from 1509/10. The two saints at the left, Cosmas and Damian, were physicians. One looks at St Mark seeking guidance while his colleague points deferentially to SS Sebastian and Roch, both venerated as offering protection against the plague, acknowledging the primacy of spiritual resources in fighting the epidemic – a view at that time fully justified since plagues were regarded as a visitation of God and there was no effective medical treatment. St Mark sits aloft in pro-consular dignity as he receives divine guidance in his role as the protector of Venice, but the shadow cast over him implies the epidemic was not over, so the altar may rather be something of a call to arms.

The first and best known of an early series of Madonnas and Holy Families in a landscape setting is *The Gypsy Madonna* (p. 16), so called because of her dark eyes and dusky complexion. In contrast to the remoter Madonnas of Giovanni Bellini, the *Gypsy Madonna* has a radiating warmth, an expansive physicality, but the composition still derives from a Bellini prototype (p. 17, top). In the Bellini, the child faces directly out, and X-rays show this was originally the case with the Titian. They also demonstrate how Titian adhered to the Giorgionesque practice of making radical changes during the painting process. This differed from earlier generations of Venetian artists and central Italian artists, who were more likely to have worked everything out beforehand in preparatory drawings or underdrawing on the support and less likely to make major alterations after starting to paint.

In the more complicated *Holy Family with a Shepherd* (p. 17), there are still signs of inexperience in the lack of body structure under the Virgin's drapery, the unbalanced pose of Joseph and uncomfortable-looking shepherd. The *Madonna and Child with SS Catherine and Dominic and a Donor* (p. 18) in the Magnani

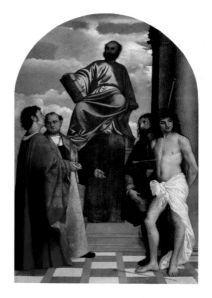

***St Mark Enthroned with SS Cosmos, Damian, Roch and Sebastian**, c. 1512*
Oil on panel, 230 x 119 cm
Venice, Santa Maria della Salute

St Mark is inspired by the enthroned monarch in Sebastiano del Piombo's *Judgment of Solomon*, while St Sebastian on the right derives from the same saint on a series of organ shutters painted by Sebastiano for the Venetian church of San Bartolomeo di Rialto.

***Salome with the Head of John the Baptist**,*
c. 1511–1515
Oil on canvas, 89.3 x 73 cm
Rome, Galleria Doria Pamphili

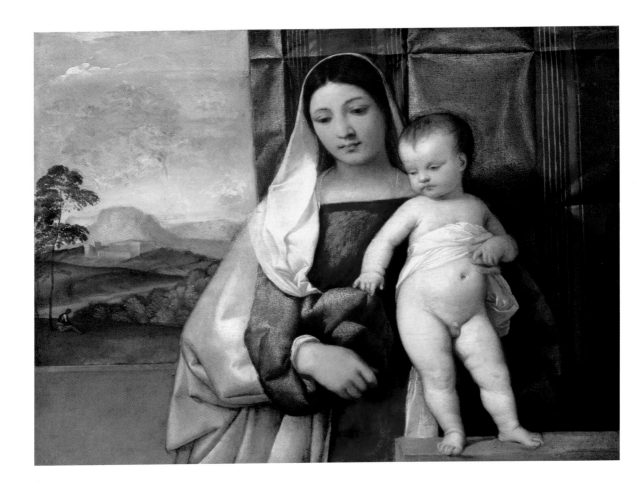

The Gypsy Madonna, c. 1511
Oil on panel, 65.8 x 83.5 cm
Vienna, Kunsthistorisches Museum

Rocca foundation is much larger and more ambitious. Few Titians have such *bonheur de vivre*, such matutinal freshness, and the Virgin's blazing red drapery reinforces the ardor of her supplicants. In a picture on this scale, Rome would have been in Titian's mind and the monumental contrapposto of the Virgin seen from low down may have been inspired by Michelangelo's Prophets and Sibyls in the Sistine chapel, which Titian had not seen but would certainly have heard about. In the more relaxed and confident *Madonna and Child with SS Dorothy and George* (p. 19), Titian brings the charms of the family circle to the well-tried formula of the Sacra Conversazione. St Dorothy's indulgent smile is that of a visiting relative while the noble St George irresistibly recalls the avuncular bore, always right, taking himself very seriously, and full of the best and dullest advice. The green curtain bracketing the brighter colors of the figures supports this mood of secure domesticity.

Venice in the 16th century was like Paris in the Belle Époque – a city of light. Above the inevitable slums and squalor, palaces and public buildings gleamed with marbles looted from all over the Mediterranean, their luster heightened by reflected light from canal and lagoon. Then, as now, Venice had the character of a pleasure capital: her courtesans were world famous and authorities com-

plained that their lavish dress made them hard to distinguish from noblewomen. In such a setting, one might readily expect a demand for images of beautiful women, and Titian's early series of female portraits are one of the glories of the Venetian Renaissance. Depicted with loving care, his sitters – however idealized in the final composition – are too full of life and character not to have been taken from the model.

The *Woman with a Mirror* (p. 21) is probably among the earliest of these works: in comparison to others in the series, she is seen from a more frontal angle behind the parapet and in terms of atmosphere appears less integrated within the ambient space. She stands between two mirrors held up by an admirer in such a way that she can see herself and her admirer and we can see her from both front and back. This arrangement refers to the claims of painting to surpass sculpture, by presenting an all-round view with color as a bonus. Her expression has little to do with vanity, a common gloss on images of women before a mirror, and shows an unaffected and dawning delight in her own attractions which the viewer, like her admirer, is expected to share. Thus the picture is a celebration of her beauty, enhanced by the possibility of its being admired from different aspects by all concerned – herself, her lover and the spectator. By contrast, the young woman christened *Violante* (p. 22) after the little violet in her bosom, and taken from the same model as St Catherine in the Magnani Rocca *Madonna,* is presented with fewer intellectual distractions, like a movie star!

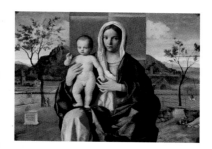

Giovanni Bellini
Madonna and Child, c. 1468
Oil on canvas, 85 x 225 cm
Milan, Pinacoteca di Brera

The Holy Family with a Shepherd, c. 1510
Oil on canvas, 106.4 x 143 cm
London, The National Gallery

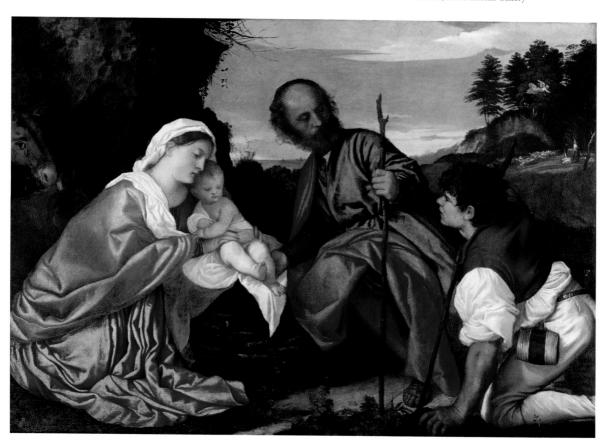

The *pièce de résistance* of this series of female sitters is *Flora* (p. 23). She has been variously interpreted as Flora the goddess of spring and of flowers and fertility, Flora the celebrated courtesan of antiquity, and as an allegory of marriage. Fundamentally, however, this is a portrait of a model posing, and it is impossible not to feel exhilarated by such an open-handed invitation to share the everyday life of the studio. Her expression is acquiescent and friendly and in the statuesque calm with which she holds the flowers and gathers up the folds of her cloak, she appears reconciled to maintaining that pose for some length of time. The silky surfaces of her flesh, smooth as marble, are among Titian's most highly wrought challenges to sculpture both ancient and modern, and her shift is arranged in the antique style. Titian's friend and supporter, the writer Pietro Aretino, described Titian's flesh tones as snow streaked with vermilion and the *Flora* is like a marble bust transfused with the lifeblood of color. She is exemplary of the way Venice absorbed and transformed antiquity on her own terms, not with reverence as in Padua or competitively as in Rome, but through a seductive mollification by color and light.

Related to Titian's series of beautiful women, but more ambitious, is his *Sacred and Profane Love* of 1514 (p. 20). The Neoplatonic title is unlikely to be displaced, but in recent times the painting has been interpreted more as an allegory of conjugal love, celebrating the marriage of Nicolò Aurelio (whose coat of arms

Madonna and Child with SS Catherine and Dominic and a Donor, c. 1512/13
Oil on canvas, 138 x 185 cm
Mamiano (Parma), Fondazione Magnani Rocca

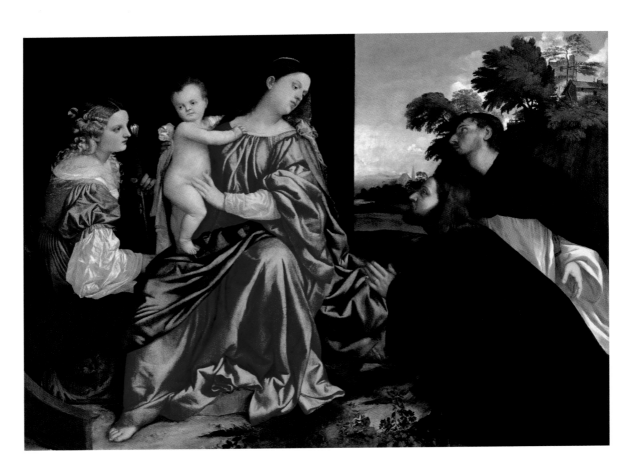

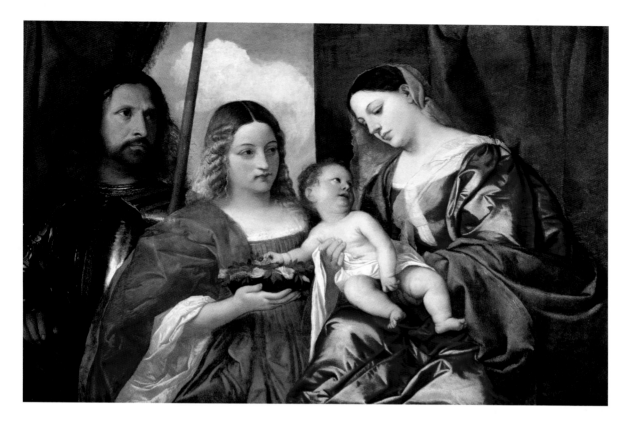

appears on the sarcophagus) to Laura Bagarotto of Padua in May 1514. The clothed woman is not a portrait, but based on a studio model, and with her white satin dress and unbound hair, for example, bears many of the traditional attributes of a bride. Her companion, who bears a close resemblance to her, lacks the specific attributes of Venus and stands for marital love. She leans over encouragingly, holding up the lamp of love in a gesture of promise, while her cloak, of the bridal color red, twists and turns passionately in the windless air. The bride herself, however, is still too shy and virginal to acknowledge her sponsor. The supporting role played by the landscape, pre-figured in the slightly earlier *Three Ages of Man* (pp. 28–29), is now stage-managed with perfection. To the left the trees protect the young woman and the sunlight is warm and caressing, while on the right the view is more open and the light harder, prophetic of the increased freedom women enjoyed after marriage and the new challenges they faced.

The same female model reappears in *Salome with the Head of John the Baptist* (p. 14), in which Titian consciously readdresses the art of Giorgione in the softer light and colors and in the complementary contrast of red and green so important in the *Castelfranco Madonna* (p. 9). At the instigation of her mother, whom the Baptist had censured for her incestuous marriage to King Herod, Salome had demanded the Baptist's head as a reward for dancing at Herod's birthday. The cupid lurking under the arch refers to an old tradition of Salome's unrequited passion for her victim, hinted at by the wanton strand of hair on her cheek and the saint's locks spilling off the charger and over her arm. The maid with half-

Madonna and Child with SS Dorothy and George, c. 1516–1520
Oil on panel, 86 x 130 cm
Madrid, Museo Nacional del Prado

X-rays show that both the child and St George originally faced outwards, which would have made the picture more old-fashioned and more formal.

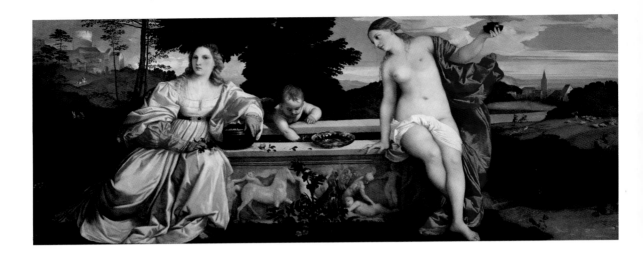

Sacred and Profane Love, 1514
Oil on canvas, 118 x 279 cm
Rome, Galleria Borghese

The painting was commissioned by Nicolò Aurelio, who had been a member of the Venetian Council of Ten and was involved in the execution of the bride's father and first husband for treason, following Venice's temporary loss of Padua during the War of the League of Cambrai in 1509–10.

PAGE 22:
Violante, c. 1514
Oil on canvas, 64.5 x 50.8 cm
Vienna, Kunsthistorisches Museum

The sitter was once thought to have been Titian's mistress and the daughter of the artist Palma Vecchio, who also painted a series of Venetian beauties.

PAGE 23:
Flora, c. 1515–1520
Oil on canvas, 79.7 x 63.5 cm
Florence, Galleria degli Uffizi

In the 17th century, the *Flora* came to the Netherlands and inspired Rembrandt to paint his wife Saskia in the same guise, albeit less scantily clad.

Woman with a Mirror, c. 1514
Oil on canvas, 93 x 76 cm
Paris, Musée du Louvre

open lips has a speaking role, like Giorgione's *Old Woman* (p. 7), but in this case more coyly suggestive. Her bovine features scarcely imply a great mind, but she is clever enough to have guessed her mistress' secret and seemes to impart her discovery with a look of complicity. Salome inclines her head to listen, smirking in cynical amusement at her maid's perspicacity and in satisfaction at having got even with the man who rejected her. The head of the Baptist is perhaps a self-portrait and the anecdotal slyness of the painting, anticipating 17th-century Dutch genre painting, may refer to a long lost and irrecoverable joke.

The Bravo (p. 25), so called because of the mysterious armed man with his back to us, also falls into this Giorgionesque phase and demonstrates a more obvious undercurrent of cruelty. The subject has been convincingly identified as the arrest of Bacchus by Pentheus, King of Thebes, who opposed the Bacchic cult. Bacchus' revenge was dire, and Pentheus was torn to pieces by his mother and sisters. The look of vindictive outrage on the god's face strikes home and the folly of alienating the Olympians was a theme to which Titian would return in some of his most memorable late works. The closeted intimacy of *The Bravo* is repeated in *The Tribute Money* (p. 24) painted for Duke Alfonso d'Este of Ferrara in 1516 as the door to his medal cabinet. The insidiousness of the Pharisee, proffering the coin with the dexterity of a conjurer, is contrasted with the massive spiritual authority of Christ as he looks his challenger in the eye and tells him to render unto Caesar what is due to Caesar, and unto God what is due to God.

Titian was the first Italian artist to acquire a truly international clientele, and this owed much to the fame of his portraits. Portraiture provided a constant stimulus for his interest in psychology as well as an opportunity to meet and cultivate potential patrons. His artistic goals conformed to the expectations of a time when portraiture was more and more being used to fashion a self-conscious public image: an adequately flattering likeness, an account of the sitter's public or private status that impressed or at least was of some interest, and a record of character that was sufficiently reticent not to be intrusive or offensive but enough to bring the subject to life. It had been commonplace since antiquity to praise artists for making their sitters come alive, but the repeated praise Titian received in this respect indicates he was perceived as breaking new ground. He does this in two ways: first, by describing his sitter's personality or state of mind

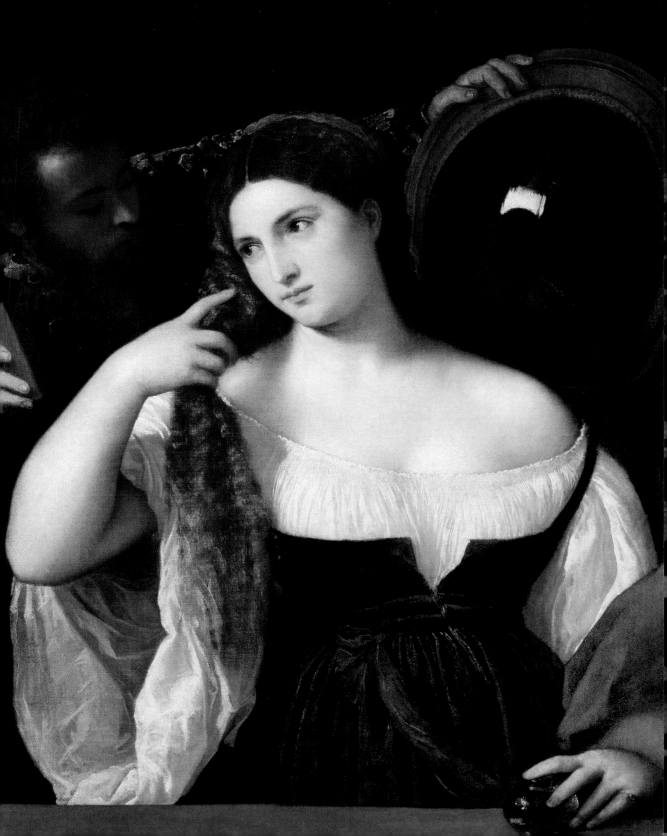

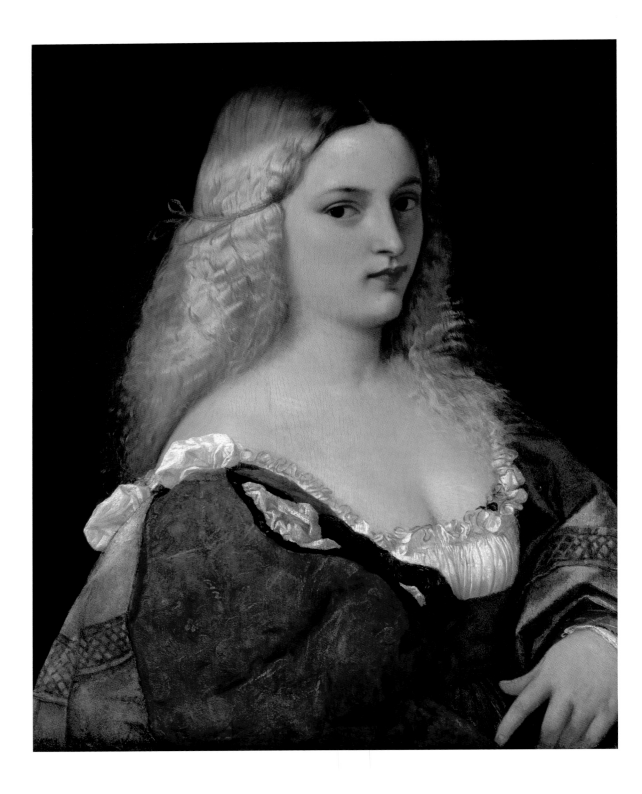

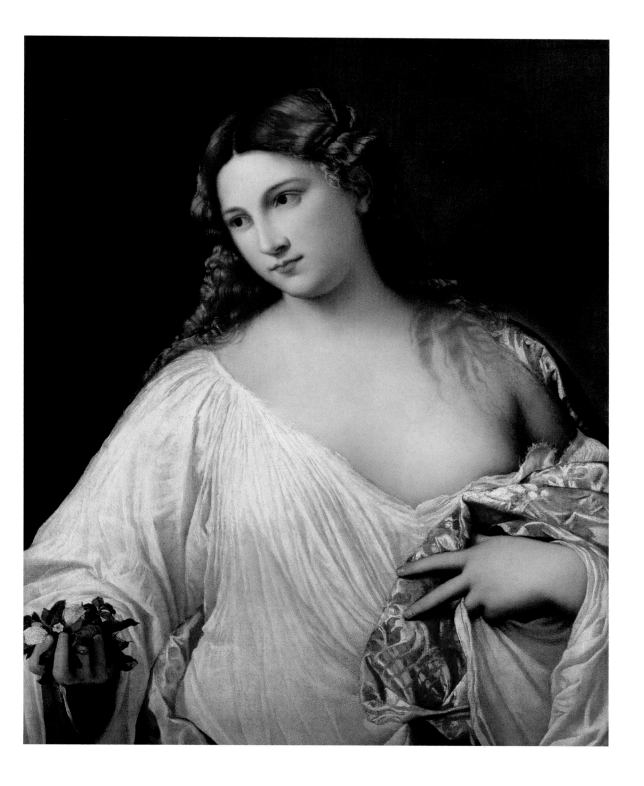

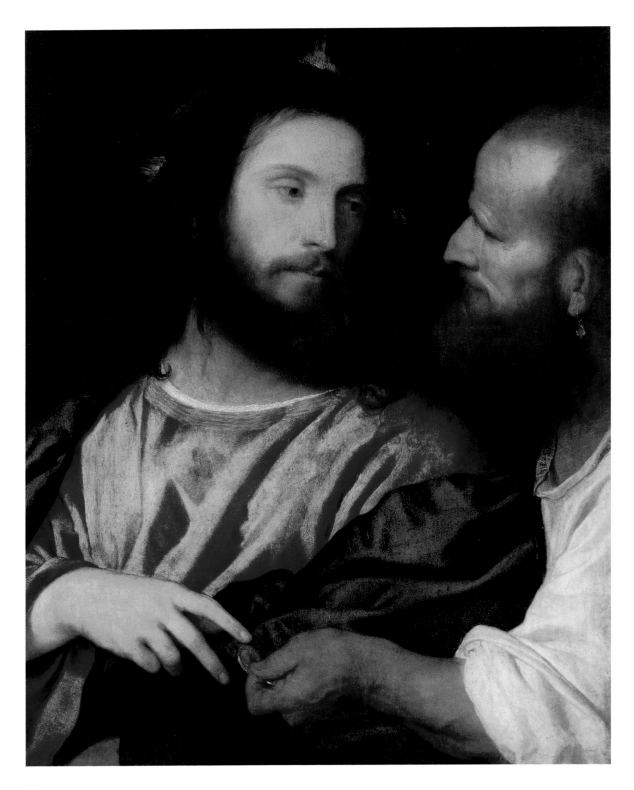

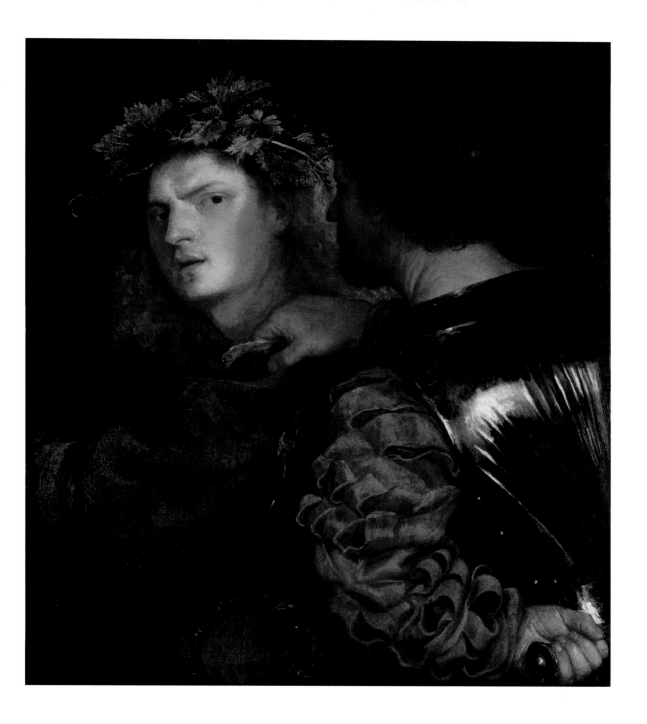

The Bravo, c. 1516/17
Oil on canvas, 75 x 67 cm
Vienna, Kunsthistorisches Museum

The Tribute Money, 1516
Oil on panel, 75 x 56 cm
Dresden, Staatliche Kunstsammlungen,
Gemäldegalerie Alte Meister

"Render therefore unto Caesar the things that
are Caesar's, and unto God the things that are
God's" (Matt. 22:21) was a fundamental text for
relations between Church and State, and sound
advice for the patron Alfonso d'Este, who owed
allegiance to both the Pope and the Holy Roman
Emperor.

much more clearly and specifically than other Italian Renaissance artists, with
the notable exception of Raphael; secondly, by marrying this psychological prof-
ile with an indication of the sitter's social standing – always an essential function
of portraiture – in a way that allows the artist to flatter under the guise of telling
the truth. Titian must have been aware of the nature of his skills since, according
to his 17th-century biographer Carlo Ridolfi, he recommended the Bergamask
painter Giovanni Battista Moroni for those who just wanted a plain honest like-
ness.

The experimental variety of Titian's early portraits is illustrated in his *Portrait
of a Young Man* in the Frick Collection, New York. The sitter's aspect is that of
privileged youth, but instead of the dandified arrogance of the *Man with the Blue
Sleeve* (p. 6), his reflective eyes show a dash of poetic melancholy – like a "Hamlet
of the lagoons" in John Shearman's phrase. Titian particularly likes to reveal
character by his treatment of the mouth, and here the set of the lips can be seen
as sensitive or irresolute according to taste. Titian also gilds the image with a
spectacular and impressionistic display of fur painting, set off by the flat areas of
color in the hat, in which as much is taken for granted as in a late Rembrandt.

In the votive picture of *Jacopo Pesaro being presented by Pope Alexander VI to
St Peter* (p. 27), Titian harnesses the burgeoning psychological skills of his por-
trait practice to a broader narrative context. The Pope in question had died in
1503, and the painting was ordered at some later time in thanksgiving for a minor
naval victory over the Turks and the recapture of the island of Santa Maura in
August 1502. The Venetian fleet was under Benedetto Pesaro and Jacopo Pesaro
commanded the Papal galleys. Jacopo, who was also bishop of Paphos, is shown
in the deep purple robe of a Knight of Malta holding the papal banner. There are
undeniably awkward passages: the squared pavement ends too abruptly at the
water, while St Peter is installed on top of the carved plinth rather like a curator,
complete with keys, lecturing in a museum of antiquities. However, in Pesaro's
profile, Titian has laid bare his subject's state of mind with understanding and
admiring frankness. Though the commission was in thanks for victory, the ad-
miral is shown not after the battle but before, the downward curve of his lips
betraying apprehension as well as entreaty. The Pope, belying his fearsome repu-
tation, supports his protégé with compassionate gravity as the brocade of his
cope glistens like the tesserae of a mosaic. With the helmet lying ready at hand
and the galleys preparing to sail, the composition serves as a most moving tes-
tament to Venice's desperate need to maintain maritime supremacy and the con-
stancy of her faith in divine aid.

The Three Ages of Man, c. 1512
Oil on canvas, 90 x 150.7 cm
Edinburgh, Duke of Sutherland Collection, on
loan to the National Gallery of Scotland

The subject is not entirely clear but appears to
have cyclical overtones. The sleeping children
are protected from injury or death from the tot-
tering dead tree stump by Cupid, who then fuels
their passion as young adults but cannot prevent
old age and death. The juxtaposition of the sage
with two skulls with the dead tree and protec-
ting cupid suggests a pattern of rebirth.

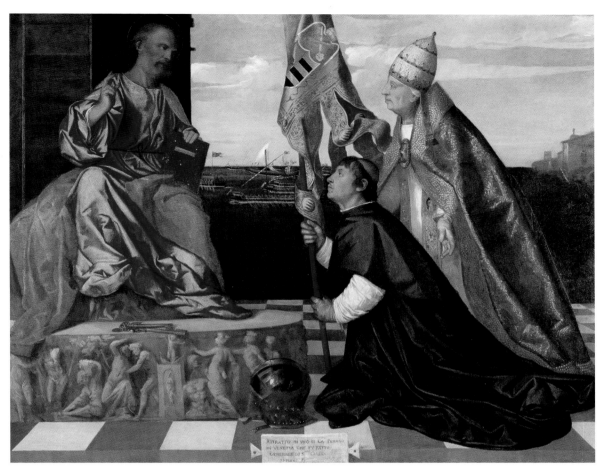

Jacopo Pesaro being presented by
Pope Alexander VI to St Peter, c. 1506–1511
Oil on canvas, 145.5 x 183.5 cm
Antwerp, Koninklijk Museum voor
Schone Kunsten

Due to its awkward passages, this used
to be considered one of Titian's very earliest
paintings and dated c. 1506.

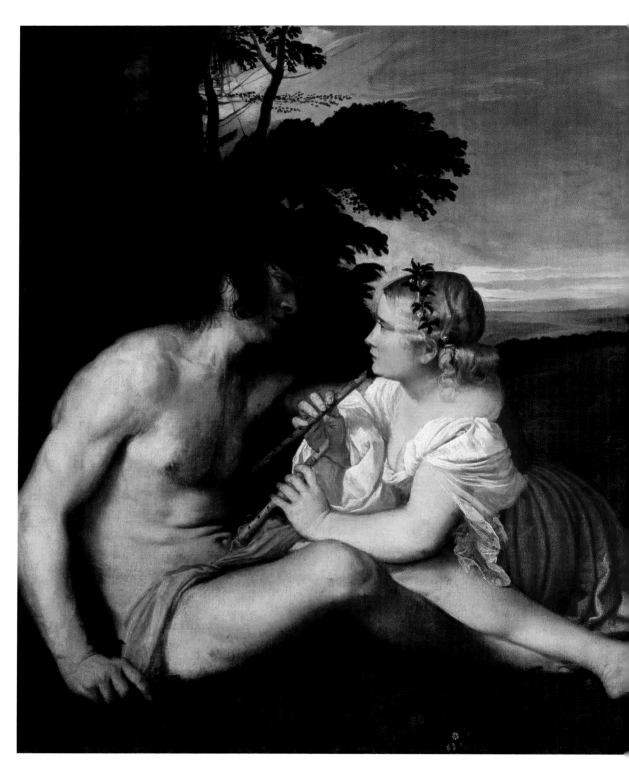

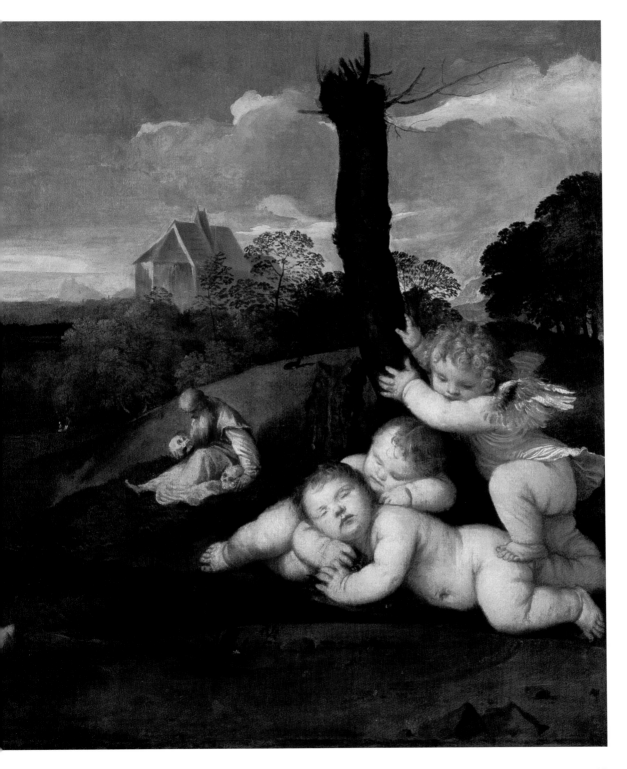

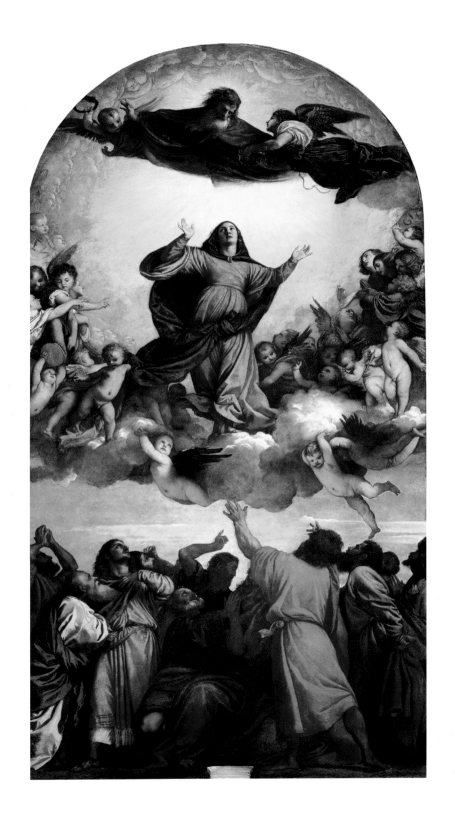

Fame and Wider Horizons: The *Assumption of the Virgin*, the *Pesaro Madonna* and the Ferrara *Bacchanals*

Ever since his first public commission for the Fondaco dei Tedeschi, Titian had been a candidate for official recognition, and in 1513 he was invited to Rome by the humanist Pietro Bembo. Instead Titian preferred to apply for a government sinecure, amounting to official recognition as painter to the Venetian republic, which he received in 1517 after the death of Giovanni Bellini. Somewhat earlier he had also been awarded a commission to replace a decayed 14th-century fresco of a battle scene in the Grand Council Hall of the Doge's Palace with a substitute on canvas. This was not completed until 1538, only to be destroyed by fire in 1577.

Titian soon decisivly confirmed his artistic pre-eminence in Venice with his *Assumption of the Virgin* (p. 30), painted between 1516 and 1518 for the Frari Church, a full-blown masterpiece on a heroic scale, fit to stand with Michelangelo's Sistine Chapel and Raphael's Stanze in Rome. The basic organization is simple: the earthbound apostles are defined within a rectangle, while the ascending Virgin and God the Father are loosely inscribed in a circle, signifying eternity. The two groups are linked by a steep triangle with its base in the two apostles in red and its apex in the Virgin, denoting her translation from earth to the heavenly sphere. Typical of Titian's realism is the way the Virgin does not levitate but walks forward naturally as she is carried aloft on the cloud. The widening gap separating her from the apostles is expressed by the gesticulating apostle in the foreground, whose fingers reach in vain toward the cloud base, and by the swinging putto to the right, the tips of whose toes have just risen above the head of the apostle in green. To control such energy Titian has developed a mastery of chiaroscuro: the restless mass of putti on the cloud segment are unified by a band of shade and the dark cloak that defines and directs the Virgin's dynamic contrapposto. The Virgin herself is set before a furnace of light against which the boldly foreshortened God the Father hovers not unlike a giant bat. Titian had so far evaded going to Rome, but he would have kept abreast of the latest developments by questioning visiting artists and amateurs and accumulating drawings, prints and statuettes. His impressions would have left him in no doubt that he had some catching up to do, and this competitive pressure from points south must surely have inspired such unrelenting energy distributed over so monumental an armature. In the opinion of a contemporary Venetian critic, Lodovico Dolce, the *Assumption of the Virgin* combined the grandeur and *terribilità* of Michelangelo with the charm and idealization of Raphael and the colors of nature. The gigant-

Martino Rota
after Titian
The Death of St Peter Martyr, c. 1568
Engraving, 40 x 27.1 cm, after a destroyed altarpiece in SS Giovanni e Paolo, Venice

Titian's fleeing friar is based on Michelangelo's *Crucified Haman* from the Sistine Ceiling, and his sprawling martyr on Raphael's tapestries of the *Death of Ananias* and the *Conversion of Saint Paul*.

Assumption of the Virgin, 1516–1518
Oil on panel, 690 x 360 cm
Venice, Santa Maria Gloriosa dei Frari

The light falling on the figures within the painting replicates the actual fall of light through the windows in the apse where the painting hangs.

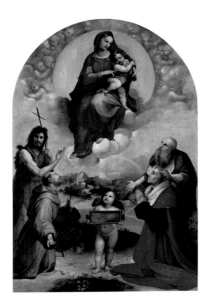

Raphael
Madonna di Foligno, c. 1511
Oil on canvas transferred from panel,
320 x 194 cm
Rome, Pinacoteca Vaticana

*Madonna and Child with SS Francis and
Blaise and the Donor Alvise Gozzi*, 1520
Oil on panel, 312 x 215 cm
Ancona, Museo Civico

In the distance, below the Virgin, are the Doge's
Palace and the Campanile. The donor came
from Ragusa, on the opposite side of the Adria-
tic to Ancona; hence the painting reaffirms
Venetian control of the Adriatic, a dominance
that had recently come under threat.

ism of the apostles is certainly Michelangelesque, the contrapposto of the Virgin
a Raphael trademark, and the palette elemental, dominated by red, green and
white. Titian thereby presented Venice with a new, electrifying vision of a spirit-
ual event from which it requires an effort of will to tear oneself away. A sustain-
ing prop of Venetian mythology was the city's foundation on the day of the
Annunciation, so the *Assumption of the Virgin* readily took its place as an icon
of the divine favor underpinning the city's destiny.

Titian's awareness of Rome becomes more specific in a smaller altarpiece
painted shortly afterwards for Alvise Gozzi of Ancona (p. 33). The relation of the
donor and his sponsor, and of the Virgin and Child to both, is clearly inspired by
Raphael's *Madonna di Foligno* (p. 32). However, the Titian can equally well be
seen as a younger brother to the *Assumption of the Virgin*, especially in the warm,
ruddy light and the monumentality of the saints.

Less broadly painted and more highly crafted is the polyptych in SS Nazzaro e
Celso in Brescia commissioned by Altobello Averoldi, papal legate to Venice, in
1518/19 (p. 34). The format of five panels is old-fashioned, but the dynamic rela-
tion between Christ and St Sebastian, predicting the triumph of both, anticipates
the Baroque. Titian openly vies with sculpture in the two main figures, taking
inspiration from the recently discovered Hellenistic statue of Laocoön and – in
the case of Sebastian – one of the slaves from Michelangelo's tomb for Julius II.
He shows as much of the saint's back and front as he can and endows his flesh
with a richly tinted marble-like sheen that both absorbs and reflects the light.
Such meaty realism is not seen again until the great Baroque realist, Caravaggio,
whose birthplace, the small town for which he was named, lies between Brescia
and Milan. One can just imagine how the latter would have admired the way in
which Sebastian's toes grip the overturned column as he continues to resist,
while the rope digs into the inert flesh of his raised right arm, revealing that this
part of his body has already succumbed.

The *Assumption of the Virgin* spread Titian's fame far and wide and set the
seal on an Italian if not yet international reputation. His first triumph on the
mainland was in Ferrara. Here Alfonso d'Este, who had commissioned *The Trib-
ute Money* (p. 24), conceived a project in emulation of the Studiolo of his sister
Isabella d'Este in Mantua, namely to bring together a group of mythological
works by Italy's most celebrated artists to decorate his Camerino d'Alabastro in
the castle of Ferrara. Titian was not his first choice: in 1514 Bellini had already de-
livered a *Feast of the Gods*, whose landscape Titian was later to repaint. When the
contributions invited from Fra Bartolommeo in Florence and Raphael in Rome
failed to materialize, however, the Duke had to fall back on Titian, at this point in
time still less well-known. Since the market for mythological cycles of this kind
did not exist in Venice, Titian was thereby handed a golden opportunity to broa-
den his repertoire with a series of three Bacchanals. The first painting in this se-
ries is *The Worship of Venus* (p. 35), whose subject is Love as the source of fertility
and regeneration in nature. Titian's composition is based on a description by the
late antique writer Philostratus, in his *Imagines*, of a painting of cupids gathering
apples in the presence of Venus amid a tree-girt landscape. In fact, the painting
may never have actually existed; its description may rather be an example of
literary ekphrasis, in which the pleasures of looking at various different works of
art are evoked in suitably poetic language. Aretino was later to write about Titian
in a similar fashion. For Philostratus himself, color, as in Venetian art, was an
essential life-giving form, not the mere superficial ornament it was held to be
within the standard classical tradition. His text would have been translated, since

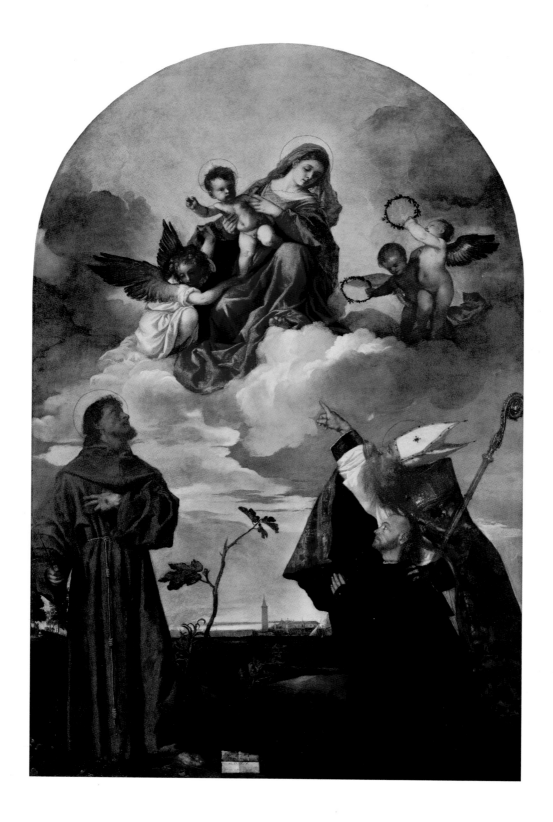

Titian had little Latin and less Greek and *The Worship of Venus* follows it very accurately. Indeed, the calligraphic precision with which the cupids are rendered endows them with a quasi-literary charm, as they bubble, frolic and gambol like the swirling waters of a river in spate irrigating the verdant landscape. Like the landscape background, Venus and her companions are painted more tonally than the putti, whose crisply rendered bodies evoke the shiny surfaces, juicy fragrance and even crunchiness of the apples they gather.

Titian's sources for the next picture in the series, *Bacchus and Ariadne* (p. 37), were Catullus and Ovid. Entering the National Gallery in London in 1826, its

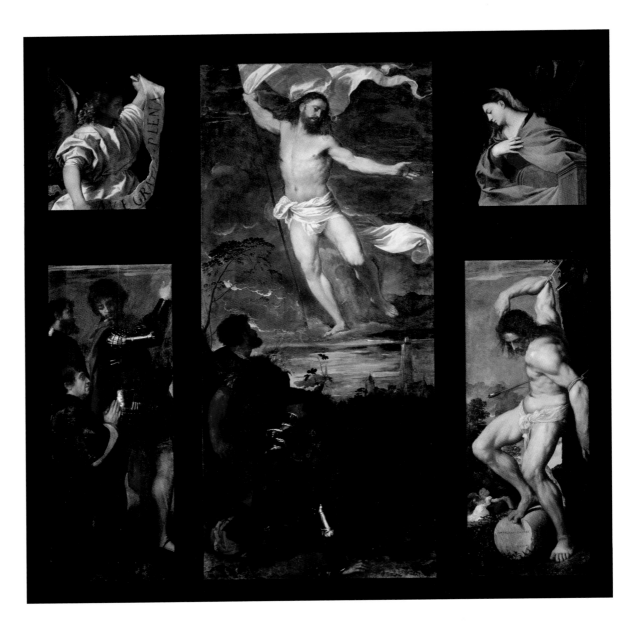

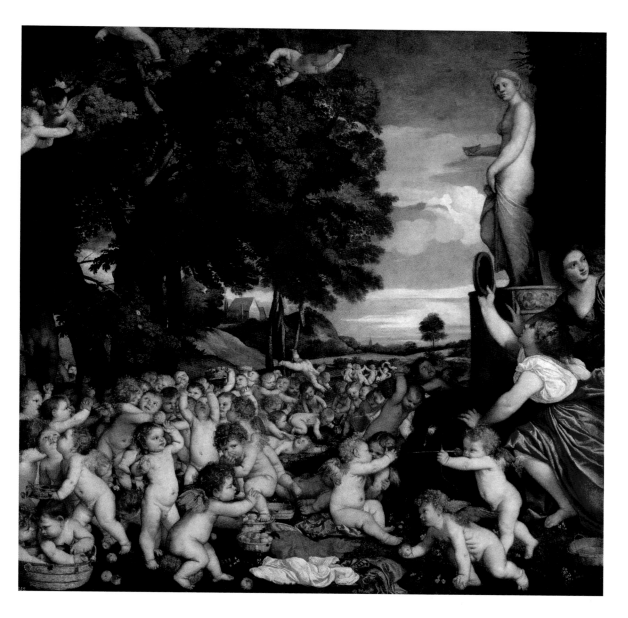

breezy Mediterranean buoyancy is like a rest cure from depressing weather and *fatigue du Nord*. Bacchus' behavior is equally un-British as he leaps smitten by love from his chariot; his crimson cloak sings out like a shout of admiration as Ariadne pulls up in a mixture of alarm and attraction. Crowe and Cavalcaselle, Titian's great 19th-century biographers, are very eloquent on this masterpiece: "There is no single composition by Titian up to this time in which the scene and the dramatis personae are more completely in unison... In the warm air of Naxos it seems natural that leopards [they are actually cheetahs] should be gentle beasts of draught. In the horns and hairy legs of a youthful faun we discover nothing that is monstrous and that snakes should harmlessly twine round the legs

The Worship of Venus, 1518–1520
Oil on canvas, 172 x 175 cm
Madrid, Museo Nacional del Prado

By basing himself on Philostratus, Titian was in effect recreating a lost masterpiece of antiquity. This would have flattered the patron, who could thus compare himself to Alexander the Great, the patron of Apelles, the most celebrated painter of the ancient world.

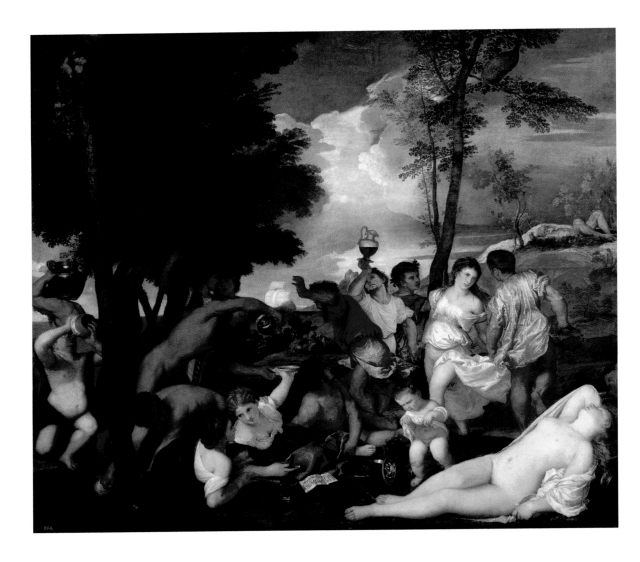

The Andrians, c. 1523/24
Oil on canvas, 175 x 193 cm
Madrid, Museo Nacional del Prado

The man leaning on his elbow in the center derives from Michelangelo's *Battle of Cascina* cartoon, while the drunken nymph to the far right is based on a classical statue of Ariadne.

and arms of Satyrs appears to be no miracle. Here too drunkenness ceases to be repulsive, and nymphs are beings of true flesh and blood whose place in the creation it is to dance in undress through the groves and clap the cymbal or shake the tambourine. It is in this power to transform a scene, the elements of which are altogether fanciful into something that strikes us as reality, that we acknowledge Titian's genius to consist."

The Andrians (p. 36) is the last of the Ferrara Bacchanals. The subject refers to the arrival of Bacchus on the island of Andros, where his followers await him in varying degrees of inebriation, as they drink from the island's river flowing not with water, but with wine. The god himself is not present, but his ship can be glimpsed in the distance and the Bacchanalian essence is exalted in the flask of wine held unsteadily aloft. The shifting shadows may evoke the checkered moods of intemperance, but there is no moral disapproval and the mood is elegiac and tolerant. As with *The Worship of Venus*, the choice of subject may reflect not only

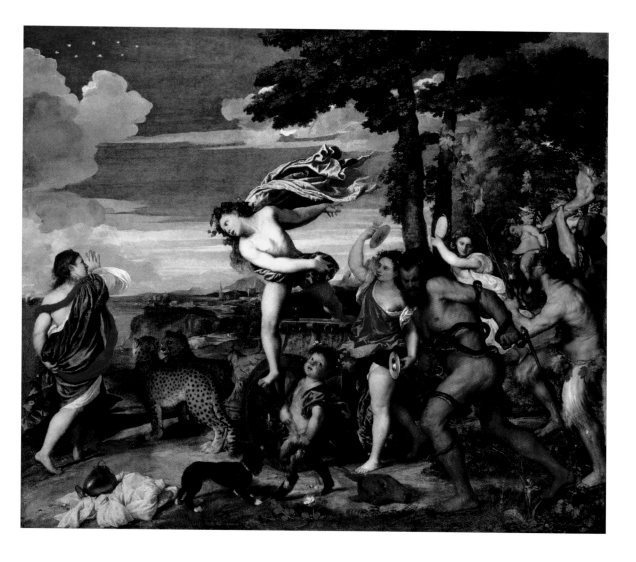

the hedonism of the patron but also the agricultural prosperity of the Ferrarese countryside, replete with food and drink.

After the *Assumption of the Virgin*, Titian's next major religious painting was the *Pesaro Madonna* (p. 38), also painted for the Frari church. Started in 1519, it would take over half a decade to finish. Cooler and more tightly painted than the *Assumption of the Virgin*, it has an aura of dynastic privilege and aristocratic grandeur. In the kneeling donor can be recognized the same Jacopo Pesaro from the votive painting in Antwerp (p. 27). By displacing the Virgin to one side, Titian allows Pesaro to view her directly and thereby combines the ex-voto format, showing the main protagonists facing each other in profile, with the traditional frontal altarpiece. The receding steps of the throne may be inviting, but the authoritarian profiles of the family members keep the public at a respectful distance. Like Venetian citizens barred from the ranks and councils of the nobility since the late 13th century, the audience may observe but not participate. St Peter

Bacchus and Ariadne, 1520–1523
Oil on canvas, 176.5 x 191 cm
London, The National Gallery

This painting is among Titian's most Raphaelesque, particularly in the contrapposto of Ariadne and the controlled energy of Bacchus and his train, who seem more numerous than they really are. To achieve coloristic brilliance, Titian has used the strongest pigments then available on the market.

presides like a great chamberlain as he looks down on his protégé with the respect due to an equal, while St Francis is more compassionate as he recommends Francesco Pesaro, in senator's robes, and his family to the Christ child. To the left a military saint with a Turkish prisoner holds a banner inscribed with the Pesaro crest surmounted by the papal insignia, a further reference to the victory over the Turks commemorated in the painting in Antwerp.

In the portraits that he executed during this same period of around 1515 to 1526, Titian suppresses technical virtuosity in favour of new strategies for depicting personality, which as we have seen are as likely to convey the sitter's social status as inner character. The famous *Man With a Glove* (p. 39) provides a definitive account of youth emerging into manhood. His upper lip sports the beginnings of a moustache, the eyes and the set of his head are wary and cautious and the collar of his shirt unfolds about his neck and head like petals around a budding flower. In adolescence different parts of the body grow at different rates, so the hands are too large and the neck rather thick, but his elegant gloves herald adult sophistication. It has been suggested that the sitter may be Ferdinando Gonzaga, a young brother of Duke Federico, who returned from the court of Spain in 1523 aged 16.

At the close of the decade, Titian completed what used to be considered one of his finest works, *The Death of St Peter Martyr* (p. 31). Tragically, it was destroyed by fire in the 19th century, but a vivid ekphrasis by Aretino describes how "you would comprehend all the living terrors of death" in the face and flesh of the man on the ground, and perceive "the pallor of vileness and the whiteness of fear" while contemplating his companion in flight. Aretino's description also brings home how realistic and shocking the image must have seemed to contemporaries. Such violence had never been seen in an altarpiece before, nor had any saint been portrayed in such a humiliating position, but Titian's solution is polemically Venetian in the importance of the landscape, whose trees soar and stir in sympathy with the drama below.

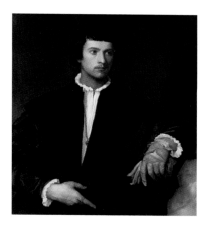

Man with a Glove, c. 1523
Oil on canvas, 100 x 89 cm
Paris, Musée du Louvre

Madonna with Saints and Members of the
Pesaro Family (Pesaro Madonna), 1526
Oil on canvas, 478 x 266.5 cm
Venice, Santa Maria Gloriosa dei Frari

Titian made great changes to the architectural background, finally deciding on the two giant columns, which are structurally meaningless but a compelling symbol of patrician grandeur.

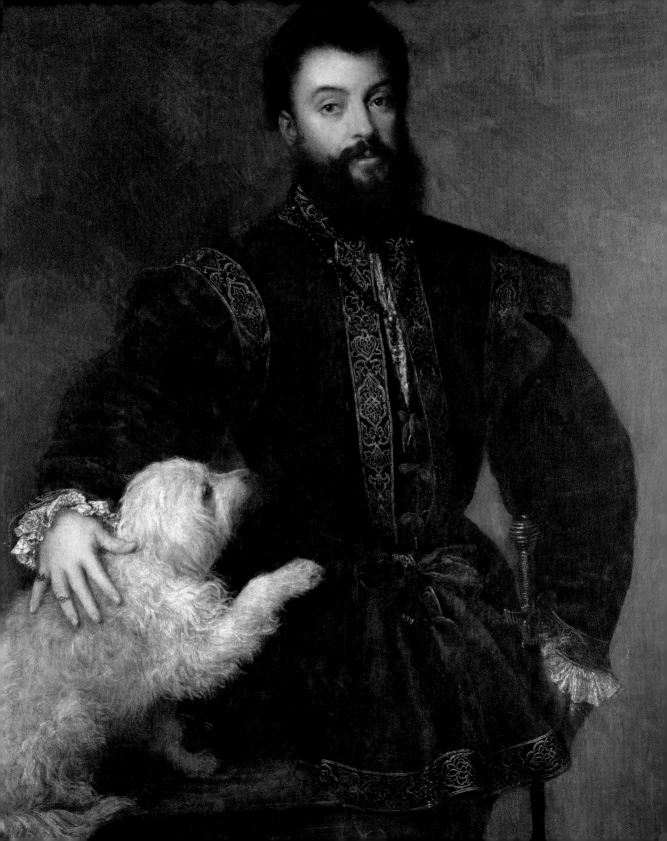

The 1530s: New Ideas and New Patrons

In the first two decades of his career Titian set parameters for the development of European art that were to be relevant for three centuries. In the *Assumption of the Virgin* (p. 30) he drew level with the Roman High Renaissance, in the *Pesaro Madonna* (p. 38) he established an enduring pattern for the classicizing Grand Manner altarpiece, in the Ferrara *Bacchanals* (pp. 36, 37) he set a standard for mythological painting valid right up to the 19th century, and in *St Peter Martyr* (p. 31) he preempted the Baroque. In the 1530s, however, there is a sense that Titian had to make a more conscious effort to maintain the pace of creative change.

Titian's most important new patron at this time was Federico Gonzaga, Duke of Mantua and nephew of Alfonso d'Este. The artist's portrait of Federico (p. 40) is of unsurpassed poise and elegance and may have been intended to support the sitter's matrimonial intentions. The flattery is not unalloyed. The Duke's love of pleasure, indicated by his sumptuous costume and the pampered dog, may be subsumed by his seigneurial dignity but the slight inclination of his head and the small sensuous mouth evoke the flippant selfishness of the same Duke in Verdi's *Rigoletto*. In 1529 Gonzaga ordered three more works from Titian. The only one to survive is probably identifiable with the *Madonna and Child with St Catherine and a Shepherd*, known as the *Madonna of the Rabbit* (p. 41). Here, Titian brings the domesticity of the Prado *Madonna and Child with SS Dorothy and George* (p. 19) out of doors. With a look of winning encouragement the Virgin restrains the rabbit, a symbol of fecundity, so that the child can clamber down and play with it. The richly dressed St Catherine, proffering her charge like a lady-in-waiting, introduces a courtly aspect, and in fact the Giorgionesque shepherd in the background may be a portrait of Federico himself: Since x-rays show that the Madonna's head was originally turned in his direction. In the foreground, the delicate wild flowers recall the *locus amoenus* or "idyllic setting" of classical poetry, and in the park-like landscape we see the Arcadia of the *Concert Champêtre* (pp. 10–11) refracted through the smiling fertility of the Ferrara *Bacchanals*. Nowhere else does Titian so successfully integrate the traditions of the Sacra Conversazione and the Pastoral.

Supper at Emmaus (p. 42) shows Titian in a less playful mood. The painting's first owners were the Maffei family from Verona, where Titian painted an altarpiece for the Cathedral, and its sonorous gravity and the way the colors traverse

***Madonna of the Rabbit*, 1530**
Oil on canvas, 71 x 87 cm
Paris, Musée du Louvre

***Federico Gonzaga, Duke of Mantua*, 1529**
Oil on panel, 125 x 94 cm
Madrid, Museo Nacional del Prado

The way the dog recognizes its master would have been seen as a conventional tribute to the power of portraiture to achieve a vivid likeness.

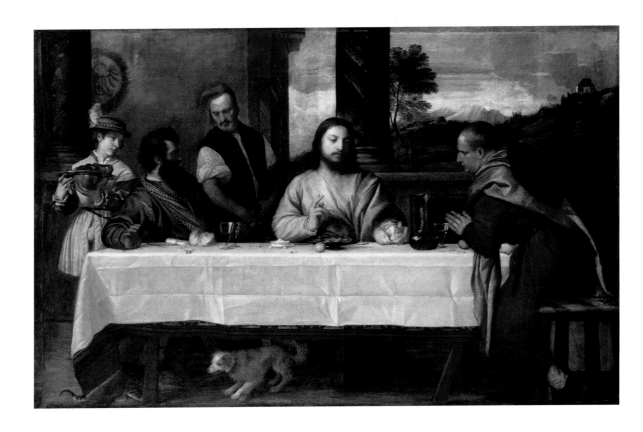

Supper at Emmaus, mid-1530s
Oil on canvas, 169 x 244 cm
Paris, Musée du Louvre

The disciple in green leaning back is modeled
on the Judas in Leonardo's *Last Supper*. Another,
possibly earlier version is in the collection of the
Earl of Yarborough at Brocklesby Park, Lincoln-
shire.

the spectrum like a progression of organ chords may take its tone from nearby
Brescia, especially the art of Moretto. Indeed, Titian may have borrowed the
striking orange-yellow of the page's costume from the similarly placed disciple in
Moretto's own *Supper at Emmaus* of around 1526, which originally hung in the
Church of St Luke in Brescia and now in the Tosio-Martinengo Museum. The
realism of the still life is also somewhat in the Lombard taste and anticipates not
only Caravaggio but also the sacramental realism of Zurbarán. Another religious
subject of this period is the *Annunciation* (p. 43), today in the Scuola di San
Rocco. Though severe in its relief format, it is handled with a lighter touch: the
Virgin is submissive and absorbed in her text, but the bushy haired angel is a
sprite, with a dash of pagan devilry as she touches down in a puff of cloud, like a
light aircraft landing in a field. Her drapery capriciously forms scrolls and curls
following the fashions of the late 15th century or a maenad of antiquity.

In 1529 Titian's relationship with Federico Gonzaga was further cemented
when the latter took him to Parma to meet and paint the Holy Roman Emperor
Charles V. The following year Charles was to be crowned by Pope Clement VII in
Bologna. This ratified Hapsburg dominance in Italy and introduced a period of
relative calm after the disruptions of Franco-Spanish rivalry in the Italian Wars
of the first decades of the century. On their first meeting Charles did not take up
the offer of Titian's services, but in 1532 the Emperor stopped off in Mantua on
his way to a second meeting with the Pope and, on Federico's recommendation,
Titian was summoned from Venice to paint him. Titian's first portrait of Charles,

a three-quarter length in armor, has disappeared, but was a great hit and earned him the rank of Count Palatine and Knight of the Golden Spur. Such favors conferred on a mere artist, however distinguished, are extraordinary given that Titian and the Emperor were barely acquainted. Titian, famed for his social graces, knew his place but enjoyed rubbing shoulders with men of power, and Charles is unlikely to have overlooked his potential as a prominent Venetian to act as a source of information on matters other than artistic. Nevertheless, their relationship seems to have been based on something deeper, some kind of profound mutual respect, and was remarked on by contemporaries. A second portrait of the Emperor by Titian (p. 45), showing him standing full length with a dog, is substantially indebted to a portrait by Jacob Seisenegger in Vienna. Titian projects his subject's masterful personality more convincingly, however, by focusing on the Emperor's height, choosing a lower viewpoint and restricting ambient space. The favors shown Titian by Charles V also brought commissions from his entourage, notably the Marchese del Vasto, an important general and a highly respected patron of the arts.

From the 1530s onward, Titian's career would be advanced not only by an increasing number of high-ranking clients, but also by the promotional talents of his friend, Pietro Aretino. Born in Arezzo of humble origins, Aretino joined the household of the banker and patron of Raphael, Agostino Chigi, in Rome. By 1525 he had offended enough people to be obliged to leave, and he reached Venice in 1527 at the same time as the architect Jacopo Sansovino, who had fled Rome after the Sack. Co-opting Titian, the writer and the architect formed an artistic triumvirate that controlled the Venetian art world until mid-century. Aretino has been called the first modern journalist. Since Venice was the most liberal state in

Annunciation, mid-1530s
Oil on canvas, 166 x 266 cm
Venice, Scuola di San Rocco

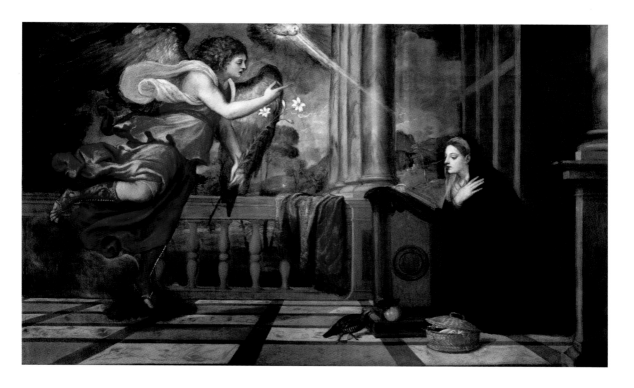

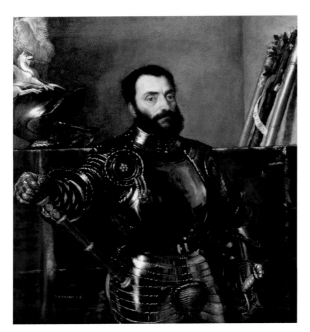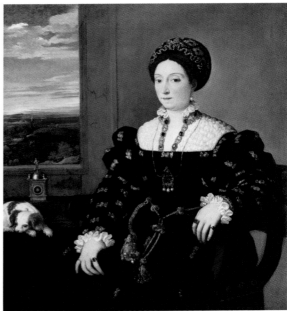

ABOVE LEFT:
Francesco Maria della Rovere, Duke of Urbino,
1536
Oil on canvas, 114 x 103 cm
Florence, Galleria degli Uffizi

ABOVE RIGHT:
Eleonora Gonzaga, Duchess of Urbino,
1536/37
Oil on canvas, 114 x 103 cm
Florence, Galleria degli Uffizi

Charles V Standing with His Dog, 1533
Oil on canvas, 192 x 111 cm
Madrid, Museo Nacional del Prado

Italy and a haven for political and intellectual refugees, he could flourish there with impunity, writing pamphlets and open letters to the great and the good, sometimes flattering or cajoling, sometimes literary blackmail. He also wrote comedies for the stage and pornography, and his letters are an open window on the times. As he said, "I try to depict the nature of others with the vivacity with which the miraculous Titian depicts a face." Aretino was a greedy, lecherous bully, but he could be loyal and generous and became Titian's closest friend and most tireless supporter. Promoting Titian's portraits proved particularly fruitful. After a portrait was finished and even in some cases when he had yet to see it, Aretino would praise the work in a letter or poem dedicated to the sitter, which would then be published. This enabled him to pursue and cultivate Titian's increasingly important roster of clients, to whom he would on occasion send a Titian portrait as a gift, thus expanding the catchment area of potential supporters or victims.

Two Titian portraits to which Aretino applied his networking talents are of the Duke and Duchess of Urbino. The portrait of the Duke (p. 44, left) is more openly biographical, endorsing the sitter's martial valor and career as a successful condottiere. In fact he was a rather brutal man, which he needed to be to survive in so combative a profession. He commanded both the Florentine and Venetian armies and refused an offer to enter the service of Charles V. Behind him are a parade helmet and batons recording his service with Florence and the Papacy and, intertwined, an oak branch referring to his family name della Rovere and a banderole inscribed with a motto *se sibi* ("by himself alone"). In a letter and sonnet written to Veronica Gambara, poetess and ruler of Correggio, Aretino praised the portrait for its virility and martial ardor, but however flattering Aretino's interpretation, the Duke could not escape Titian's penetrating vision. The eyes deep in their sockets show a man tired and worn out whose career is nearly over, and after the portrait's completion the Duke was dead.

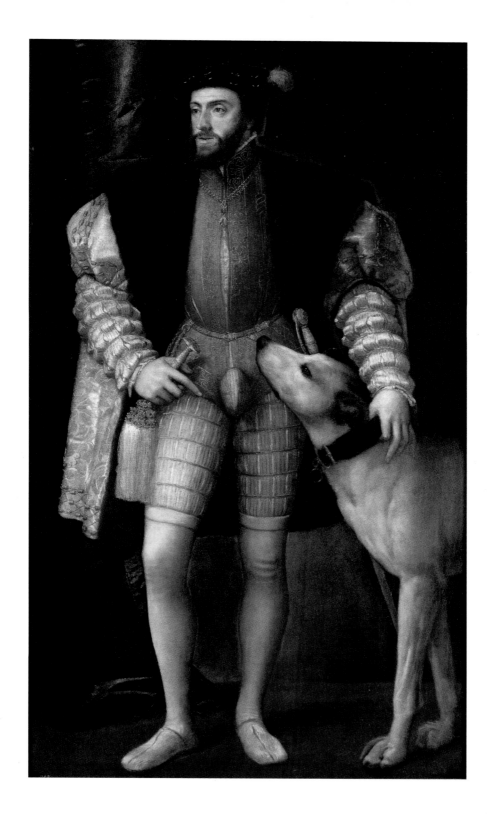

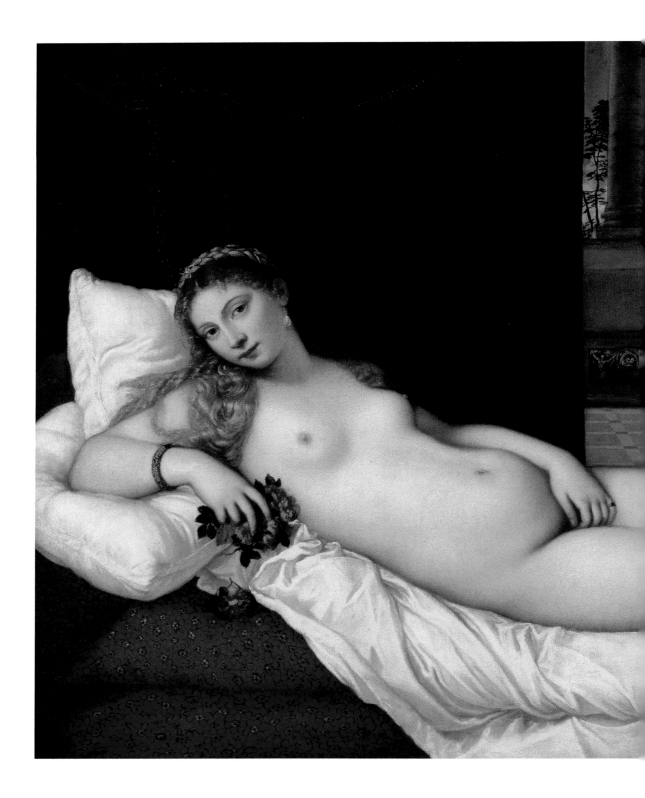

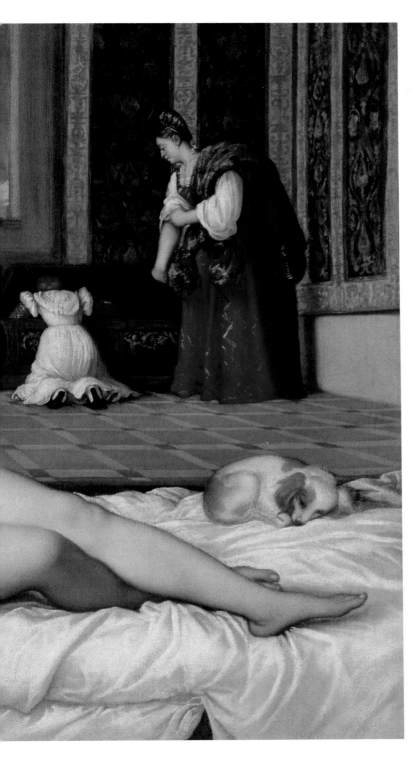

Venus of Urbino, before 1538
Oil on canvas, 119 x 165 cm
Florence, Galleria degli Uffizi

The dog, the roses held by Venus, and the myrtle plant on the window ledge are all symbols of the constancy of love.

The Penitent Magdalen, c. 1533
Oil on panel, 84 x 69.2 cm
Florence, Galleria Palatina

Giorgione and Titian
Sleeping Venus, c. 1510/1512
Oil on canvas, 108 x 175 cm
Dresden, Staatliche Kunstsammlungen,
Gemäldegalerie Alte Meister

Originally attributed to Giorgione, it is now
thought that Titian reworked or finished most
of the picture except for the nude.

Titian's *Duchess of Urbino* (p. 44, right) was born Eleonora Gonzaga but wears the black and gold colors of the Montefeltro family from whom her husband had inherited the Dukedom. In her youth she was praised by Pietro Bembo for her beauty and by Castiglione for her virtues, and the dog and the German clock from Augsburg or Nuremberg allude to her fidelity and moderation and perhaps simply to a liking for clocks and dogs. A laudatory sonnet by Aretino extols Titian's skill at conveying her modesty, honesty and prudence, but as with the portrait of her husband, Aretino is only concerned with her official character; beneath her self-control, Titian has managed to invest her with a tight-lipped exasperation as if she had a lot on her plate and a lot to put up with. This was no doubt the case since the Duke was often away fighting while Eleonora was left in charge of the Duchy, whose rolling hills appear in the landscape vignette.

The most celebrated Titian of the 1530s is the *Venus of Urbino* (pp. 46–47), an indoor version of Giorgione and Titian's much earlier *Sleeping Venus* (p. 48) and more provocatively seductive. The *Venus* was acquired by Guidobaldo della Rovere, heir to the Duke of Urbino, in 1538, but not necessarily commissioned by him. He refers to the painting in a letter to his agent simply as the "nude lady", so her identification as Venus may be erroneous; certainly, she lacks the typical attributes of Venus, such as a cupid. Like *Sacred and Profane Love, Venus of Urbino* is now considered to be a marriage picture, specifically an allegory of conjugal love, and the two chests in the background may allude to cassone or marriage chests for the clothes of the bride, which in the previous century were sometimes decorated with a reclining female nude inside the lid. The compositional grid has been very carefully balanced so that an air of domestic calm and

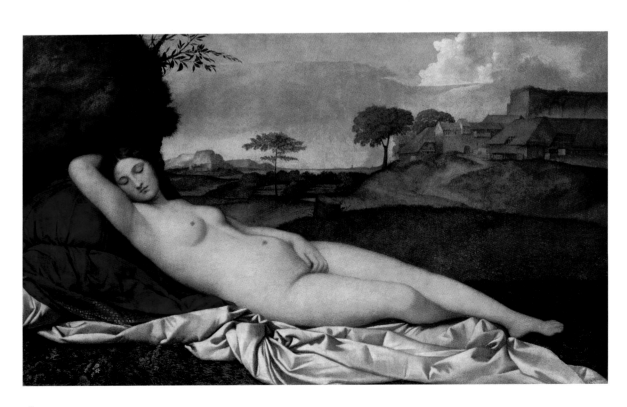

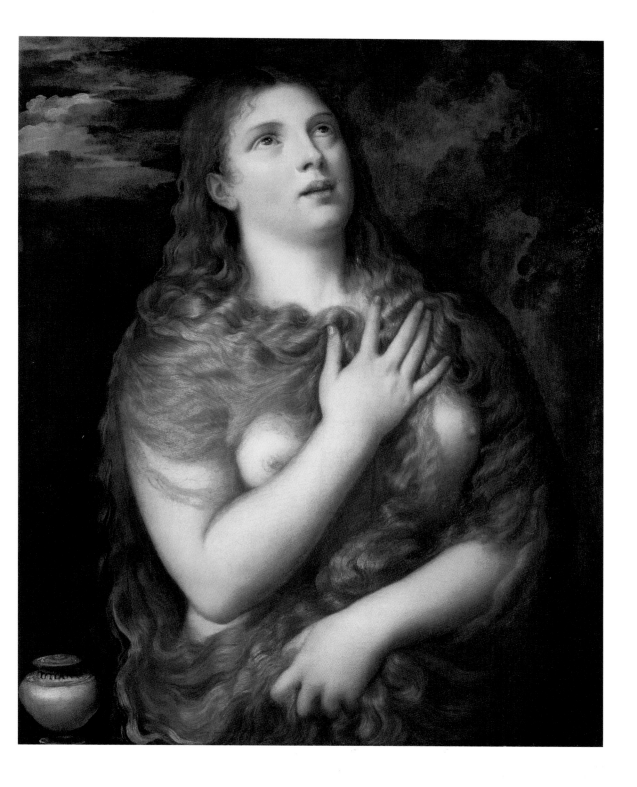

Isabella d'Este, Duchess of Mantua, 1536
Oil on canvas, 102 x 64 cm
Vienna, Kunsthistorisches Museum

Isabella commented that Titian's portrait was "so pleasing that I doubt that at the age I am represented I could have possessed all the beauty it contains."

La Bella, 1536/37
Oil on canvas, 89 x 75.5 cm
Florence, Galleria Palatina

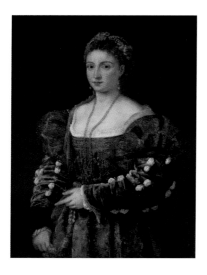

order prevails. A shallow rectangle, the couch, is surmounted by two nearly square rectangles, the screen and the vignette of the room. The edge of the screen, coinciding with her hand placed on her vulva, anchors the nude at the point of equilibrium. Her expression and self-stimulation are an open statement of friendly sexual invitation innocent of any of the voyeurism which the 19th century found it impossible to avoid associating with so seductive an image and which drove Manet to respond with such polemical corporeality in the *Olympia*. The Venus is unlikely to relate to Guidobaldo's own marriage, which took place four years before he acquired the picture. It is more probably a generalized invitation to connubial sex and the procreation of beautiful children, which it was believed the contemplation of beauty could influence. Since at the time of the marriage, Guidobaldo's bride was only ten years old, the arrival of the picture four years later would have been timely.

Titian's *La Bella* (p. 50, below) in the Galleria Palatina, probably completed around the same time for the Duke of Urbino, has a rose-like beauty that has never quite gone out of style. The model is the same as for the *Venus of Urbino*, and like the *Venus of Urbino* she should perhaps be read allegorically. She holds a paternoster, a symbol of devotion, and points to what may be a fur stole over her right arm. Until the picture is cleaned, this will remain hard to read. Stoles of ermine, for example, were common, and in art ermine symbolizes purity, in which case the lady's outward beauty would be joined by moral virtue and thus be more worthy of admiration.

In his *Isabella d'Este* (p. 50, above), Titian combines the category of the anonymous beauty with that of the portrait. By 1536, when she saw it finished, Isabella, one of the most admired and sophisticated women of the Renaissance, was a lot older than she looks here, and Titian was specifically asked to make use of a portrait by Francia as a guide to her earlier appearance. He was clearly never expected to produce anything close to a likeness, but to render a flattering evocation of her appearance when young. Famed for her elegance, she wears a turban of her own design. Whatever the limitations of such a likeness, Titian manages to endow her with a feisty personality that evokes her wide-ranging abilities and imperious manner.

The anonymous beauty is also the starting point for Titian's *Penitent Magdalen* (p. 49) in the Galleria Palatina, the first of many variations on the theme. The Magdalen, as a former prostitute converted to Christianity, was venerated as an outstanding symbol of penitence and because the intensity of her physical passion had been transformed into an equally passionate love of the divine. In Titian's painting her tresses envelop her body like fire, sensuous yet all-consuming and transforming, and the view of Titian's contemporaries that his Magdalens aroused feelings of compassion rather than lasciviousness should at least be given some credence. In Titian's case, however, it seems unlikely that he would have wanted to pass up the opportunity of getting the best of both worlds. Indeed, the Florentine Baccio Valori reports a conversation he had with Titian in 1559, where the painter showed him a Magdalen in the desert and joked that she had been painted on the first day of her fast, so that Titian could show her as both penitent and attractive.

As a Venetian subject, Titian enjoyed the benefits and protection of the most liberal state in Italy. There he could lead a less trammeled life than at court in papal Rome or Madrid, where he was at various times invited to settle. Titian's subtlest evocation of the civic pride of his adopted city is his *Presentation of the Virgin* (p. 51), which he painted between 1534 and 1538 for the Scuola Grande di

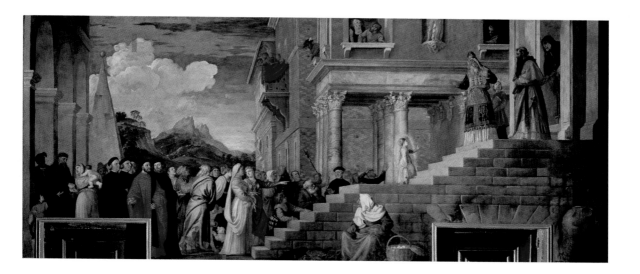

Santa Maria della Carità. This later became part of the Accademia where the picture hangs today still in its original setting. The Venetian *Scuole* ("schools") were mutual benefit societies and charities whose administrative positions were only open to citizens (roughly the equivalent of an upper middle class), and not to the aristocracy. This enabled opportunities for public service to be extended to a group who were disenfranchised politically, since only patricians could vote. *The Presentation of the Virgin*, while anticipating the grandiose architectural pageants of Veronese, ratified the continuing validity of the earlier tradition of Carpaccio and the Bellini family, who had all painted cycles for the Scuole. Thus the figures are arranged with documentary clarity in an old-fashioned relief composition. To the left are the officers of the Scuola, fairly bursting with good sense, one of whom dispenses charity to a woman with a child. The building behind the loggia has a diaper-patterned wall taken from the Gothic Doge's Palace, but Venice's continuing prosperity in the present is paraded in the loggia itself, whose classical Roman style is that of the ongoing renovation of the Piazza San Marco by Jacopo Sansovino, a refugee – as mentioned earlier – from the Sack of Rome. At a focal point in the distance, Titian has set the jagged crests of the mountains of Cadore, a pointed reminder in a civic context that he was not a native Venetian and valued a measure of independence from his adoptive city. None of these undertones would have such resonance without the tiny Virgin so central to the myth of Venice, who dominates the crowd and the giant priestly figures above her. Surrounded by a halo of light, she imparts a misty brightness to the area of the steps and the loggia which outshines the mellower daylight directed from the left. As representative of the new dispensation, she is set above the egg-selling hag and the antique torso below the steps, symbols of fallen Judaism and paganism.

The Presentation of the Virgin, 1534–1538
Oil on canvas, 335 x 775 cm
Venice, Galleria dell'Accademia

A 1553–1556 version of the subject, the *Madonna dell'Orto* executed by Titian's rival Tintoretto, retains the tiny Virgin as a centerpiece, but goes out of its way to be different by arranging the steps in steep perspective.

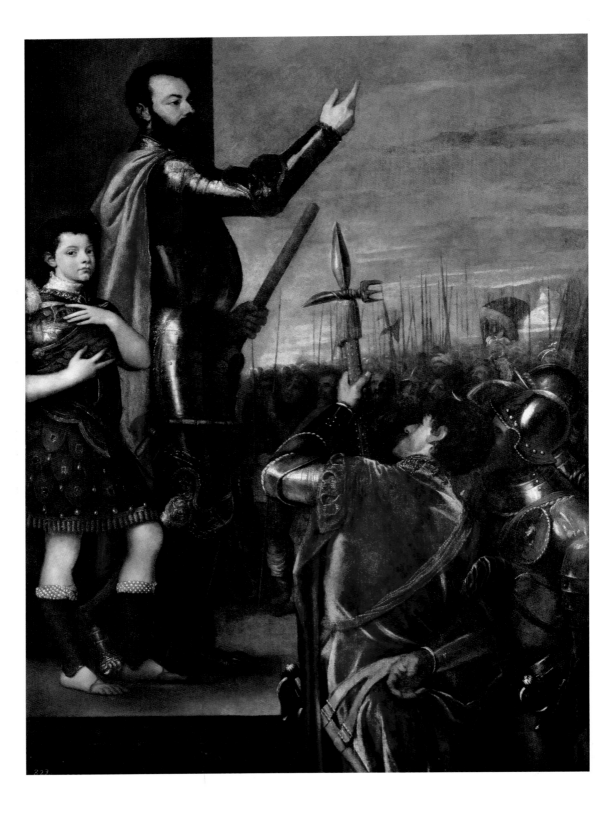

Papal Patronage and Give and Take with Rome

In the late 1530s and in the 1540s Titian, until fairly recently, was thought to have contracted a kind of virus called "Mannerist Crisis", the implication being that he felt threatened by Michelangelo and developments in central Italy and struggled to come to terms with them. Francesco Salviati and the artist and biographer Giorgio Vasari, two leading Florentine mannerists, had visited Venice around 1540, and Titian in turn went to Rome in the middle of the decade, both to pursue papal patronage and to secure a benefice for his unsatisfactory son, Pomponio. However, as will be seen in his paintings, his attitude emerges as more conciliatory and exploratory than defensive, and the same spirit of co-existence between artistic ideas in Rome and Venice is reflected in contemporary art theory. Thus although, in his second edition of the *Lives of the Artists* of 1568 Vasari polemically criticized the Venetians for paying too little attention to drawing and preparation, which also carried the stigma of lack of intellectual rigor, this hostility is less apparent in the earlier edition of 1550. In 1548, the critic Paolo Pino recommended as an ideal Michelangelo's draftsmanship combined with Titian's color, and Aretino was equally even-handed regarding Venice and Rome, that is until snubbed by Michelangelo in response to persistent requests for the gift of a drawing. In the 1550 edition of the *Lives*, Vasari had only mentioned Titian in passing since his emphasis was on artists already dead, so in 1557, Lodovico Dolce published his dialogue, *The Aretino*, to redress the balance in Titian's favor vis-à-vis Michelangelo and Raphael. Dolce, following Pino, defines the basic requirements of good painting as draftsmanship, powers of invention, and color and tone. He believed Titian to be the equal of Michelangelo and Raphael in the first two instances, and their superior in the third. He also implies, with good reason, that Titian has more in common with Raphael, and gives Titian a further boost by praising Raphael at Michelangelo's expense, claiming him to be Michelangelo's equal as a draftsman but superior in variety of invention and color. Thus, while introducing a competitive element into the equation, even Dolce seeks a measure of reconciliation between the two cultures and probably would not have seen them as poles apart.

In his three ceiling paintings for the Church of Santo Spirito in Isola, today in the sacristy of Santa Maria della Salute (p. 53), Titian does indeed approach a Mannerist sense of complex movement and foreshortening, but even here he responds as much to the challenge of illusion as of style. In two somewhat earlier

The Sacrifice of Isaac, mid to late 1540s
Oil on canvas, 328 x 284.5 cm
Venice, Santa Maria della Salute

The Marchese del Vasto Addressing his Troops, 1539–1541
Oil on canvas, 223 x 165 cm
Madrid, Museo Nacional del Prado

Aretino's face among the troops reflects his interest in del Vasto's campaigns, as recorded in his letters and pamphlets.

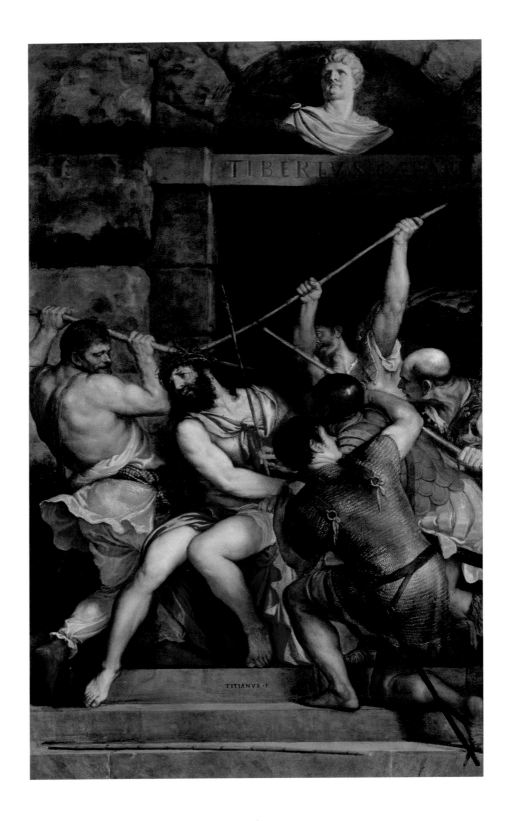

works, *St John the Baptist* (p. 55) and the *Crowning with Thorns* (p. 54), the compatibility of Rome and Venice is demonstrated in exemplary fashion. The figure of St John is consciously statuesque, slightly elongated in the Mannerist taste with firm surfaces and strong muscles, but such central Italian features are given a Venetian slant by the earthy russet tones of the flesh, the silken sheen of the lamb's wool, the rich hues of the saint's dark beard and hair and the Wordsworthian landscape. In the *Crowning with Thorns*, painted for the church of Santa Maria delle Grazie in Milan, the references to Rome become more explicit. The Christ derives from the Laocoön statue, an archetypal *exemplum doloris* ("example of pain"), while another famous antique sculptural fragment, the Belvedere Torso, provides the model for the upper body of the torturer on the left. This is a brutal scene, in which Christ's tormentors twist the crown onto his head with their canes, but the violence is relieved and Christ's suffering exalted by the beauty of the colors, which especially in the blue and green to the right are colder than usual in deference to Titian's Roman sources. In Christ's left foot extended on the steps, however, Titian pulls out all the Venetian stops and one can sense the blood flowing through the veins under the flesh. The pattern of the canes slices through the massed figures like the strokes of a knife, forming a Trinitarian triangle to the right of Christ's head. An inimitable Titian touch is the cane lying unused on the foremost step, still, shadowless and deadly, like a snake. Titian has clearly not overlooked the rumbustuous Mannerism of Giulio Romano's frescoes at the Palazzo del Te in Mantua, but the *Crowning with Thorns* is not really a Mannerist picture. Mannerism validates prolixity and artifice, but in the *Crowning with Thorns* there is nothing superfluous or unnatural: everything is very much to the point. Titian's conscious embrace of a pan-Italian style, in which the two opposing traditions of Venice and Rome are effectively reconciled, may reflect the fact that the painting was made for Hapsburg-controlled Milan.

While the *Crowning with Thorns* and *St John the Baptist* may make reference to contemporary 16th-century art criticism and theory, two other works from the early 1540s relate to the problems of a wider world. *The Marchese del Vasto Addressing his Troops* (p. 52) is a defense of the Marchese's actions in 1537, when he quelled a mutiny by controversial financial concessions to his troops. The composition depends on an antique prototype, the *allocutio*, where troops affirm their loyalty to the Emperor. In this case, however, since they are in a state of mutiny, they crowd round the dais rather threateningly. The choice of a classical format may relate to the renewed study, in the Renaissance and especially in Venice, of military textbooks by the 3rd and 4th-century authors Aelian and Vegetius, in particular with regard to improving discipline and organization. The Marquis and his troops admittedly wear contemporary armor, but the Marquis' son Ferrante, whom he had offered up as a hostage to his men, is in the garb of the Roman legions.

Ecce Homo (pp. 56–57), dated 1543, is Titian's most highly charged political statement. It was painted for Giovanni d'Anna, a Flemish merchant whose close connections with the imperial court are signified by the double-headed eagle on the shield of the stooping soldier. The patron's origins may be behind the choice of a subject that is more familiar in painting north of the Alps. This gritty masterpiece is less an exaltation of the Passion of Christ than a commentary on the difficulty of dealing with clashes of ideology under the umbrella of a superpower, be it Roman or Holy Roman; its relevance in today's world needs no emphasis. *Ecce Homo* depicts the moment when Pilate presents Christ to the

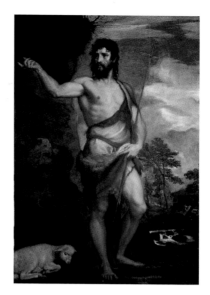

St John the Baptist, late 1530s
Oil on canvas, 201 x 134 cm
Venice, Galleria dell'Accademia

Crowning with Thorns, 1542
Oil on panel, 303 x 181 cm
Paris, Musée du Louvre

The figure of Christ is inspired by the celebrated Laocoön, an antique statue discovered in Rome in 1506.

TITIANVS
EQVES
CES
F

Ecce Homo, 1543
Oil on canvas, 242 x 361 cm
Vienna, Kunsthistorisches Museum

In Aretino's religious drama *The Humanity of Christ*, Pilate is described as sympathetic to Jesus. Titian portrays him in the same way, which may be why Pilate has Aretino's features.

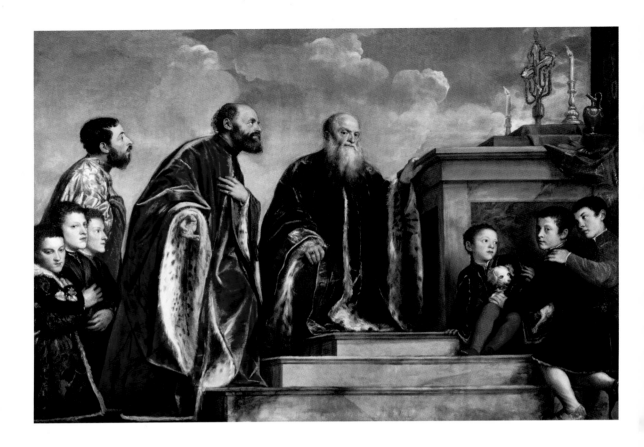

**The Vendramin Family Venerating a Relic of
the True Cross**, c. 1540–1545
Oil on canvas, 206.1 x 288.5 cm
London, The National Gallery

Titian is supposed to have said a painter only
needed three colors: white, black and red. Look-
ing at this painting, one may well believe it.

Clarissa Strozzi, c. 1542
Oil on canvas, 115 x 98 cm
Berlin, Staatliche Museen zu Berlin – Preussi-
scher Kulturbesitz, Gemäldegalerie

Aretino praised this portrait for its beauty and
naturalism, and it set a standard for child por-
traiture for centuries to come.

crowd ("Behold the man") and asks which of Christ and Barabbas he should
release. According to the 17th-century biographer Ridolfi, the composition
incorporates a number of portraits, and Titian appears to have given Pilate, dres-
sed in Marian blue as the intercessor between Christ and the mob, the features of
his friend Aretino. The dark shadows are those of an unsettled and windy day,
the line of figures undulates and swells encroachingly up the steps, and tension is
in the air as Christ is bundled unceremoniously out before the crowd, his right
leg nearly buckling under him. As in the *Crowning with Thorns*, the rusticated
architecture evokes the oppression of coercive authority. In the front the officer
with the shield crouches in an interrogatory curve, while the terrified boy with
the dog screams like an open safety valve, his eyelids tense and his hair on end.
The reactions of the crowd vary. Some wave their arms in clamorous hostility,
but the man with the halberd, like a similar figure standing before the Marchese
del Vasto, keeps one hand behind him in a gesture of moderation and willingness
to listen. He turns back sympathetically to the adolescent girl and child, who
may be modeled on Titian's daughter Lavinia, born after 1530, and Adria, one of
Aretino's children. The child is confused and seeks reassurance from the man,
but the girl is reflective and sad, a surrogate Virgin with foreknowledge of the
eventual outcome. Nearby Caiaphas, whose features derive from Roman busts of
Vitellius and Nero, protests his impatience at Pilate's vacillation. The bearded
man next to him, possibly the patron Giovanni d'Anna, looks back critically at

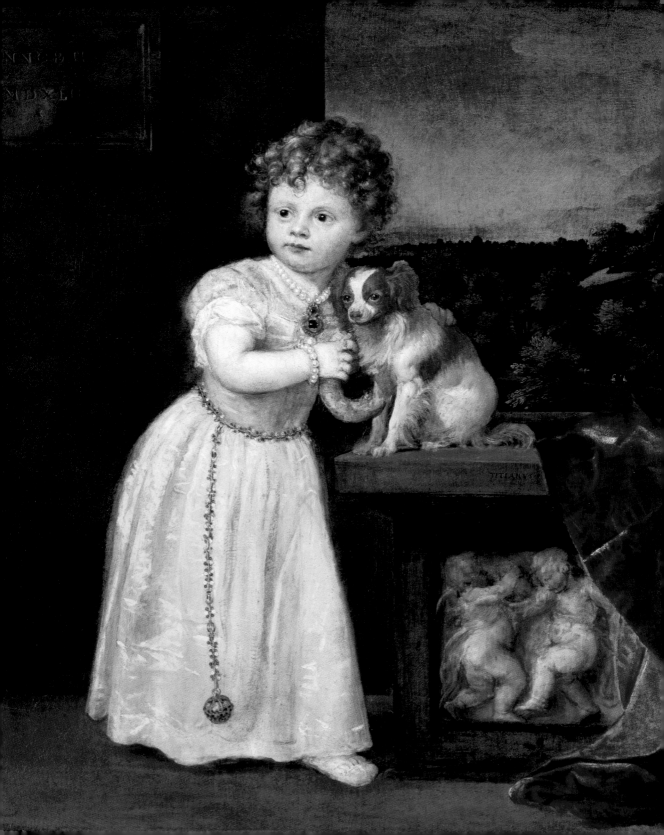

the two horsemen behind. They are Suleiman the Magnificent, a continued threat to the West especially after Charles V's failed expedition to Algiers in 1541, and a Roman commander who bears a striking affinity to the Florentine humanist Benedetto Varchi, as portrayed by Titian in a portrait of the early 1540s when Varchi was living in Padua. Whoever he is, as Roman and Turk they are both on the opposite side of the ideological fence relative to Christ, an alliance emphasized by their nuzzling steeds and the column and pillar behind which unite them. The Roman looks at Pilate but points to the back of the mailed soldier with the pike, as if to demonstrate the army's responsibility for keeping order and the need for firm action in a crisis. He thus appears as a more decisive figure than the governor. The polarization established between Christ on the far left and Suleiman and the Roman on the right, coupled with Pilate's temporizing and the imperial device on the shield, may also refer to current political conditions in the Empire. Charles V's predicament with the apostasy of the German Protestants had remained unresolved, and doctrinal differences between Catholic and Lutheran theologians had only been temporarily patched up at the Regensburg Interim of 1541. So Titian's picture serves as a grim warning that festering schism can have far-reaching consequences.

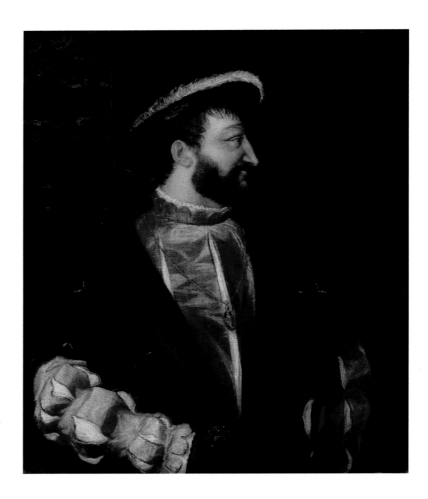

Portrait of François I, 1538/39
Oil on canvas, 109 x 89 cm
Paris, Musée du Louvre

This portrait was commissioned by Pietro Aretino for the French king, whose royal presence is here enlivened by the zest of the *bon viveur*.

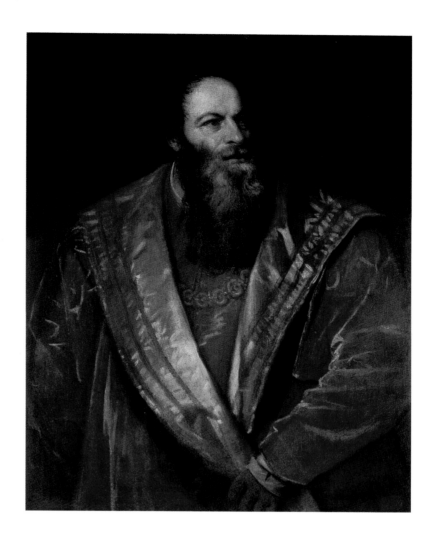

The last chapter in Titian's portrayal of civic virtue is *The Vendramin Family Venerating a Relic of the True Cross* of c. 1540–1545 (p. 58). In comparison with the earlier *Pesaro Madonna* (p. 38), the spectator is kept at less of a distance and even invited to participate. Not only are the steps brought up flush with the edge of the frame but the public is made welcome by the friendly and inclusive gaze of the patriarchal figure next to the altar. In 1369 a fragment of the True Cross that had been brought from the Holy Land was presented to Andrea Vendramin in his official capacity as Guardian of the Scuola di San Giovanni Evangelista. The Vendramin family, whose money came from the manufacture of soap, had subsequently maintained close connections with the Scuola, but as patricians they had no claim to administrative office, which was the preserve of the citizen class. This may account for the receptive attitude of the bearded man, since the family had every right to parade their identification with the relic but none to deny non-patricians a share in their homage. According to an early description of the work, it is to be inferred that the elderly bearded man is Gabriele Vendramin, an important collector who owned Giorgione's *Tempest*, while the man in profile

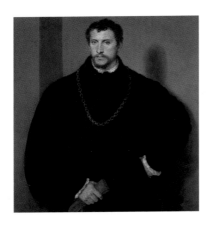

The Young Englishman, early to mid-1540s
Oil on canvas, 111 x 96.8 cm
Florence, Galleria Palatina

The silhouette would originally have been less
pronounced since the costume has darkened
over time.

Ranuccio Farnese, 1542
Oil on canvas, 89.7 x 73.6 cm
Washington (DC), National Gallery of Art

On a visit to Venice, Ranuccio had been installed
as prior of San Giovanni dei Furlani, a property
of the Knights of Malta; hence the Maltese cross
on his overcoat.

with his hand on his chest is his brother, the current Andrea Vendramin, with his
elder children behind him. Since Gabriele was actually younger than Andrea but
is here portrayed as much older, it is possible that Titian was in fact using him as
a model for the original, medieval Andrea. This might account for his propriet-
orial role at the ceremony with his hand on the altar.

As a portraitist Titian's reputation continued to flourish. One of his highest-
ranking sitters was François I (p. 60), whose portrait in the Louvre is based on a
medal by Cellini. The charming portrait of *Clarissa Strozzi* (p. 59), aged two, was
painted in 1542 when her parents were living in Venice in exile from Florence.
This is one of the earliest independent portraits of children in Italian art and one
of the first to present a child as a distinct and individual personality. With her
stylish silk dress, Titian subscribes to the convention of portraying children of
high birth as young adults. Otherwise she is a typical two-year-old, and Titian
has used her response to some distraction while feeding her pet dog as a pretext
to show her in the process of growing up, in transition from infancy to child-
hood, from amorphous incomprehension to awareness of the world about her.
The little dog looks the more focused and intelligent, but whereas she will
change the dog will stay the same. The animal spirits of the "terrible twos" are
more or less under control as she poses but are hinted at in the relief of the
energetically dancing putti.

The so-called *Young Englishman* (p. 62) has recently been cleaned, revealing
eyes of startling blue. An unattributed portrait of what may be the same sitter is
in the Accademia di San Luca in Rome, inscribed on the reverse with the name of
Ippolito Riminaldi, a Ferrarese lawyer. Titian's confrontational pose, within a
narrow space only defined by the shadow on the wall, recalls the earlier *Schia-
vona* (p. 9), but the contrast between the broad silhouette and the small head
shows traces of Mannerist taste as manifested in the portraits of Bronzino and
Parmigianino from the 1530s. The man lives and breathes in a way Aretino and
others never tired of extolling, but gives away nothing more than the minimum
demanded by good breeding at first acquaintance. Titian was clearly mesmerized
by his sitter's reserved individualism, and the incisive calligraphy of the contours
of his eyes, pointing up their differing shape, projects his gaze all the more insis-
tently. The portrait of *Pietro Aretino* (p. 61) in the Galleria Palatina, sent by the
sitter to Florence in 1545 as a gift to Cosimo I, was described by its subject as a
"terrible marvel" and later as "spectral, ghastly, necromantic" by the English
early 19th-century essayist William Hazlitt. But in truth Titian has been kind to
Aretino's dissolute, satyr-like features as we know them from other portraits and
medals. Today one can safely admire the sleeves of silk velvet conjured up so
economically by a few slashing brush strokes, but Aretino complained that the
costume was not properly finished since Titian had not been paid enough. He
may well have been covering himself in case Cosimo, who was used to Bronzino's
more finished style of portraiture, failed to appreciate it. Wearing a chain similar
to one given him by François I, and swathed in the deep red of the Venetian
patriciate, he stands ennobled by his own efforts, a potent advertisement for the
rewards available to men of talent in the liberal and tolerant embrace of the
Serenissima.

It was through Aretino in 1539 that Titian first offered his services to the fam-
ily of the Farnese Pope Paul III. After painting the Pope's grandson *Ranuccio*
(p. 63) in 1542, Titian's next commission for the family was a *Danae* (pp. 64–65)
seduced by Jupiter in the guise of a shower of gold coin. He began the canvas in
Venice in 1544 for Ranuccio's elder brother, Cardinal Alessandro Farnese, and

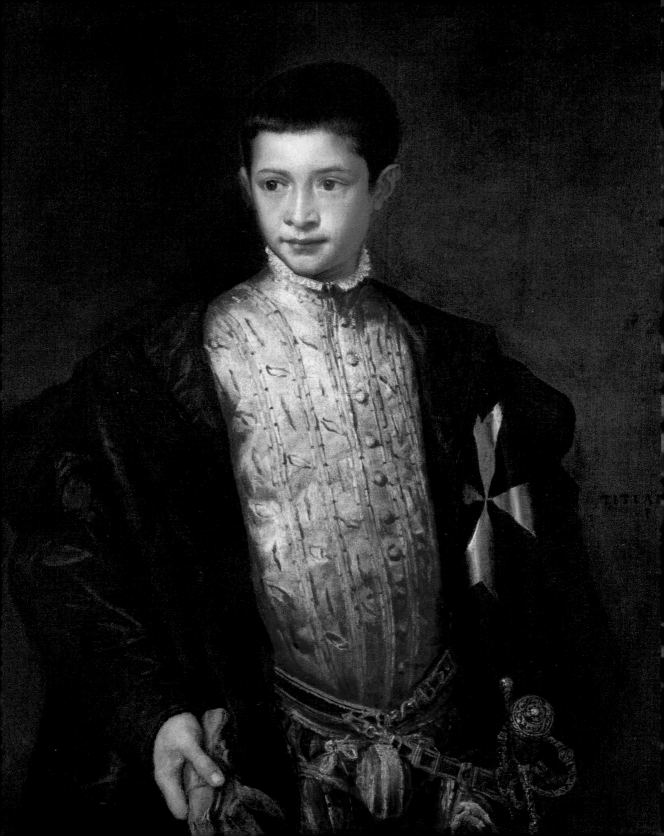

Danaé, 1544–1546
Oil on canvas, 120 x 172 cm
Naples, Museo Nazionale di Capodimonte

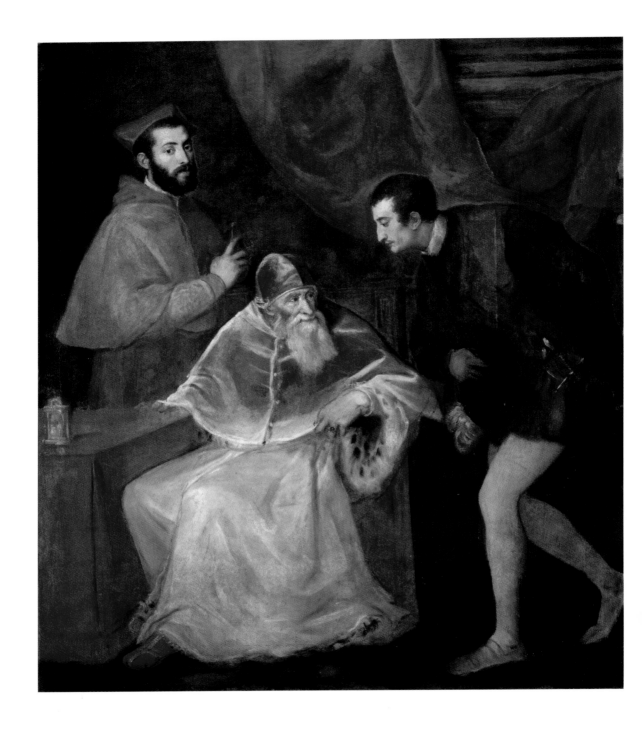

*Pope Paul III with his Grandsons Alessandro
and Ottavio Farnese*, 1545/46
Oil on canvas, 210 x 174 cm
Naples, Museo Nazionale di Capodimonte

when he left for Rome the following year, he took it with him to finish. Giorgio Vasari, the biographer and protégé of Michelangelo, brought the Master to see it. The latter was full of compliments in Titian's presence, but according to Vasari later complained that, though he liked the coloring and style, "it was a pity that in Venice they never learned to draw and that their painters did not have a better method of study." Michelangelo's criticisms seem made to order given that Vasari had an axe to grind about the superiority of Roman draftsmanship, but he might possibly also have sensed an element of provocation in the picture. The pose is obviously Michelangelesque while the cupid is based on a statue in the style of Lysippus, which Titian would have known since it was already in Venice in the collection of Cardinal Grimani. X-rays reveal an underlying composition close to the *Venus of Urbino*, but as a papal legate remarked to Cardinal Alessandro, the erotic *Danaé* made the *Venus of Urbino* look like "a Theatine nun". The model was reputedly the Cardinal's mistress, a courtesan named Angela, and outside the realm of pornography a more sexually charged image of seduction had yet to be created. Titian allows the pores of her skin to breathe under a soft yet searching light, and the way he depicts the yielding flesh on her belly introduces another dimension of tactile reality to the depiction of the nude. Thus to a Roman audience and to Michelangelo it might have appeared that Titian was deliberately trying to expose the limitations of Michelangelism by using it as a context to carry Venetian sensuality to new heights.

Titian promised to paint every member of the Farnese family, including even the cats. Having completed his first portrait of *Pope Paul III* (p. 67, below) in 1543 while still in Venice, on his arrival in Rome he embarked on a group portrait of *Pope Paul III with his Grandsons Alessandro and Ottavio Farnese* (p. 66). Inspired by Raphael's portrait of *Pope Leo X with Two Cardinals* (p. 67, above), Titian has undoubtedly caught some of the tensions of court politics, especially in the Pope's sudden and penetrating glance at the stooping Ottavio. However, it would be a mistake to see him as a Dickensian miser cornered by rapacious relatives; this is a papal audience and Ottavio is bending to kiss the Pope's extended foot, while Cardinal Alessandro stands discreetly in the background. Much of the portrait is left unfinished and Titian appears never to have been paid for it, but perhaps circumstances other than the stinginess of the client prevented Titian from completing it. It is also a most informative exposé of Titian's technique, especially in the subtle differentiations of reds and ochres – a *tour de force* of symphonic colorism – and in the way he achieves luminosity by painting the dark colors last.

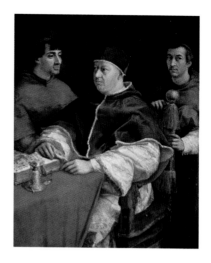

Raphael
Pope Leo X with Two Cardinals, c. 1517/18
Oil on panel, 155 x 119 cm
Florence, Galleria degli Uffizi

Pope Paul III, 1543
Oil on canvas, 113.7 x 88.8 cm
Naples, Museo Nazionale di Capodimonte

While the folds of the cope are executed with bold strokes, the face and spidery hands are more detailed and the pile of the velvet on the chair approaches *trompe l'oeil*. In this way Titian imparts a vitality that he might not have achieved with a more uniform finish.

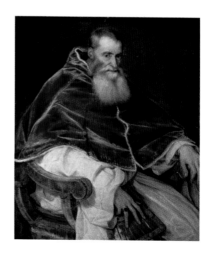

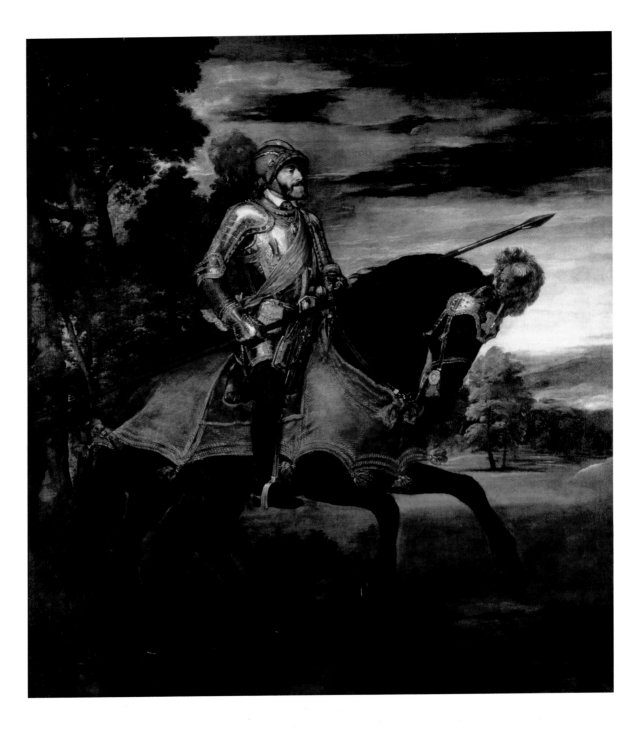

Working for the Hapsburgs: Charles V and Philip II

In 1548, Tintoretto's *Miracle of the Slave* (p. 71) was unveiled in the Scuola di San Marco. The embodiment of Paolo Pino's ideal of artistic perfection, Michelangelo's drawing combined with Titian's color, it signaled the arrival of a new star in the Venetian firmament. Titian is supposed to have ejected the young Tintoretto from his studio, and there certainly existed a grest rivalry between the two artists, who didn't get on. Born into the gentry, Titian had advanced his social status through honors conferred by Charles V, whereas Tintoretto, from humbler origins, had married into the citizen class but had fewer social ambitions. Titian preferred working for kings and princes, munificent if erratic payers who would put up with long deadlines. He could thus afford to work slowly at his own pace. Tintoretto, on the other hand, was in demand because he worked fast. Titian became a very expensive artist, but Tintoretto gave steep discounts and would sometimes work for nothing to secure a longtime client. He showed little interest in competing with Titian's increasingly international reputation and confined himself to the Venetian market, doing his best work for local institutions, some of limited means. Titian's relationship with the third great Venetian painter, the more easy going Paolo Veronese, was far more cordial, and he seems to have regarded him as his artistic heir. In 1556, judging a series of ceiling paintings by Venice's leading younger artists for Sansovino's Library on the Piazza San Marco (a commission from which Tintoretto was excluded), Titian embraced Veronese in public and awarded him first prize.

It may have been as well for Titian's *amour propre* that when the *Miracle of the Slave* was unveiled, he was not in Venice. From the end of the 1540s, Titian's relations with the Hapsburgs intensified and he began to withdraw from the Venetian market in order to concentrate on working for the imperial family. In 1548 he was summoned by Charles V to Augsburg, where the Emperor had convened a diet after his victory over the Protestant League at Mühlberg the previous year. In 1550 he was invited back to Augsburg by Philip, Charles' son and heir, whom he had already met in Milan on a grand tour of his father's possessions. Philip II, as he would become, was undoubtedly a more enlightened patron than his father, but even if Charles V attached less importance to the aesthetic qualities of Titian's paintings than to their devotional content and propaganda value, his personal relationship with Titian seems to have been even closer than his son's. The greatest image of Charles to survive his Augsburg visits is the large equestrian

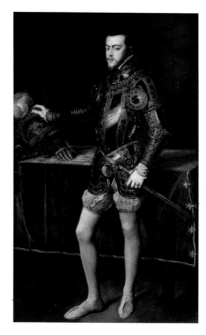

Philip II in Armour, 1550
Oil on canvas, 193 x 111 cm
Madrid, Museo Nacional del Prado

Philip wears a suit of armor made in Augsburg and today in the Royal Armory in Madrid.

Charles V at the Battle of Mühlberg, 1548
Oil on canvas, 332 x 279 cm
Madrid, Museo Nacional del Prado

Titian has portrayed the Emper as an all-seeing ruler bent on using victory to reconcile his Protestant and Catholic subjects.

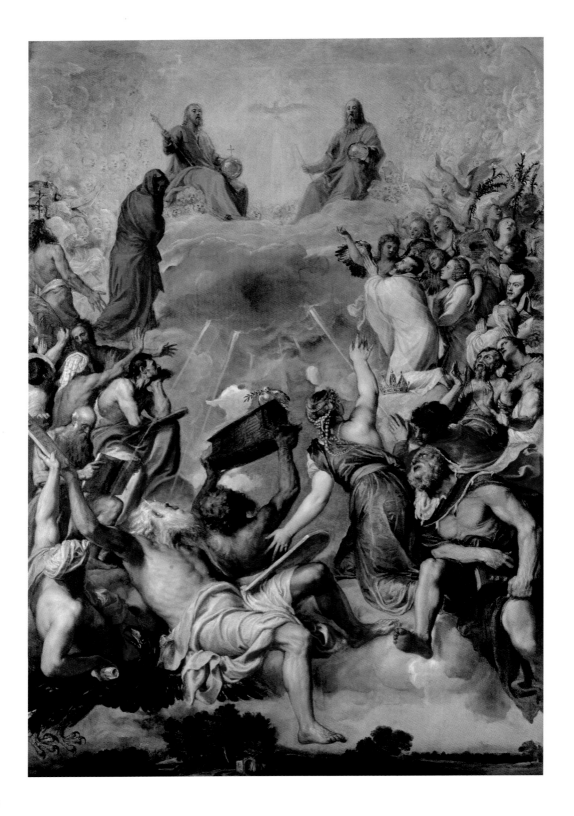

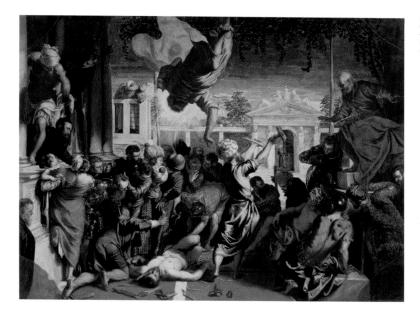

Tintoretto
Miracle of the Slave, 1547/48
Oil on canvas, 415 x 541 cm
Venice, Galleria dell'Accademia

portrait (p. 68) showing him carrying a spear and setting out for the Battle of Mühlberg. The Emperor's regal bearing, underwritten by the gilded armor and prancing warhorse, is mixed with tension and uncertainty as he summons up all the resources of an ailing body for the day ahead, and Titian's deep affection for Charles emerges in his understanding of both the Emperor's greatness and his frailty.

Charles' most cherished painting by Titian was not a portrait but the so-called *La Gloria* (p. 70). When he handed over the reins to Philip and retired to the monastery of San Juste, he took it with him and became obsessed with it as a devotional image. Below the Trinity at the top are the Virgin as intercessor and beneath her, reading anti-clockwise, Francisco de Vargas, imperial envoy to Venice, followed by various prophets and patriarchs of the Old Testament. Occupying the royal box in the divine theatre, Charles kneels shrouded and in supplication and without his crown, which is placed humbly next to him on a cloud foreshadowing his abdication. Behind are members of his family and Titian in profile next to Aretino. Charles is certainly the hidden focus of the picture, and it can be no accident that the dove with the olive branch on the roof of the ark is set right in the center, in token of a favorable reception to his entreaties.

Charles V also took two *Mater Dolorosas* with him to San Juste, including the *Virgin with Clasped Hands* (p. 72), whose look of grief, anger and resentment at the death of her son is unforgettable. Very different were the four large canvases of the *Damned* for Mary of Hungary, Charles' sister and his regent in the Netherlands. They depicted Tityus, Sisyphus, Tantalus and Ixion, all condemned to perpetual torture for incurring the displeasure of the gods. Only *Tityus* (p. 73, left) and *Sisyphus* (p. 73, right) are still extant. Tityus was sentenced to have his liver perpetually devoured by a vulture for having raped Latona and Sisyphus to carry a rock endlessly up hill for gossiping about Zeus's affair with Egira. Their gigantism is Michelangelesque, and Tityus is modeled on a Michelangelo drawing of

La Gloria, 1551–1554
Oil on canvas, 346 x 240 cm
Madrid, Museo Nacional del Prado

The inventive and varied disposition of so multifarious an array of figures points to a prolonged study of the Stanze of Raphael and the Sistine Ceiling, as do the clear local colors.

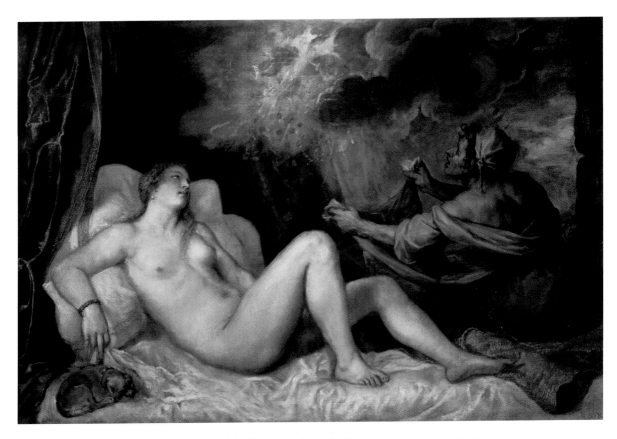

1532. In these two canvases, Titian achieves rich effects of color and chiaroscuro with a limited palette in a foretaste of his late style. As *exempla doloris*, they anticipate the martyrological imagery of the Counter-Reformation and would have been telling warnings of the perils of falling foul of authority – something Charles' rebellious Netherlandish subjects were to learn all about in the "Spanish Fury" of his son's reign.

In comparison with the portrait of his father of nearly 20 years earlier (p. 45), Philip II, in his own full-length portrait (p. 69), appears more relaxed and has more room to move in a setting of greater depth and variety. He wears parade armor like Charles in the equestrian portrait (p. 68), but whereas the latter is presented as an experienced field commander, Philip's military dress is more an expression of authority in general than of martial prowess in particular, and it was clear to observers that he had no real military inclinations. His fastidious gaze implies greater refinement, and he lays his hand gently on the helmet as if it were a work of art. Even his shoes look more comfortable and less tightly laced than his father's. At this point Philip was more familiar with Flemish than Italian art and needed time to get used to Titian. He complained that the portrait lacked finish but could hardly have asked for a more potent and refined image of power, one that was to become a principal reference point for subsequent military and court portraits.

In 1553 Philip was betrothed to Mary Tudor, a political alliance. A healthy sexual appetite and an increasing appreciation of Titian bore luxuriant fruit in what

Danaé with a Nurse, 1551–1553
Oil on canvas, 129 x 180 cm
Madrid, Museo Nacional del Prado

Virgin with Clasped Hands, 1554
Oil on panel, 68 x 61 cm
Madrid, Museo Nacional del Prado

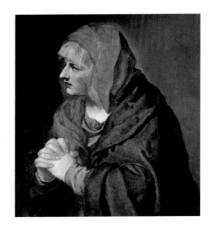

were to be the artist's most far-reaching contributions to European art, a series of mythological paintings that he referred to as the *poesie*. The term has several implications: that the pictures had a literary source, that painting and poetry made the same creative demands, and that the artist – like the poet – was entitled to a certain license in the interpretation of his sources. In these pantheistic works, whose subjects are drawn chiefly from Ovid's *Metamorphoses*, Titian deepens his sense of reality: the gods become metaphors for man's subservience to fate and forces beyond his control and agents for the remorseless ups and downs of his earthly course. The first of the *poesie* sent to Philip, *Danaé with a Nurse* (p. 72), was a more explicitly sensual version of the *Danaé* in Naples (pp. 64–65). Its pendant, *Venus and Adonis* (p. 74), was dispatched to the king in London in 1554 at the time of his wedding. According to Ovid, Venus was in love with Adonis and tried to prevent him setting out for the hunt. Adonis ignored her plea and was fatally wounded by a wild boar. In the text Adonis leaves during Venus's absence, but Titian condenses the story by showing Venus desperately trying to restrain her lover. Her pose is taken from a classical relief called the *Bed of Polyclitus*, and its exaggerated contrapposto is a conscious display of artifice much to the taste of connoisseurs in the age of Mannerism. In its own day *Venus and Adonis* was considered one of Titian's most erotic works, especially in the compression of Venus' buttocks in her seated pose, but it also suggests the indulgent condescension of a younger man towards the frantic and overprotective reaction of an older woman.

Two of Titian's best-loved *poesie* are *Diana and Acteon* (p. 75) and *Diana and Callisto* (p. 76), sent to Spain late in 1559 and today in Edinburgh. In their variety of pose, iridescent sensuality and rich colorism on a limited palette, they set an example to generations of artists from Rubens and Velasquez to Watteau and Delacroix. They have been called both Mannerist and Baroque, but in their narrative

BELOW LEFT:
Tityus, 1548/49
Oil on canvas, 253 x 217 cm
Madrid, Museo Nacional del Prado

BELOW RIGHT:
Sisyphus, 1548/49
Oil on canvas, 237 x 216 cm
Madrid, Museo Nacional del Prado

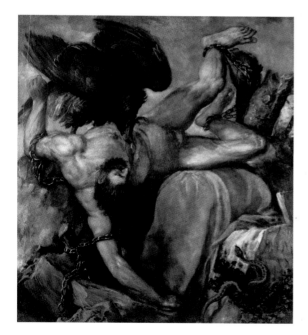

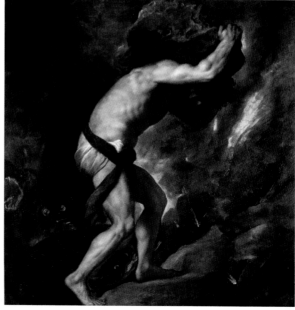

clarity they have more in common with the High Renaissance classicism of the earlier *Bacchus and Ariadne* of 1520–1523 (p. 37). The source is again Ovid's *Metamorphoses*: as a punishment for accidentally disturbing Diana and her nymphs while bathing, the huntsman Acteon was changed into a stag and torn to pieces by his own hounds. In the painting, the shock of his intrusion is compounded by the fact that he has yet to realize the full implications of the offence he has unwittingly committed. Diana, echoed by her maid, may throw him a vindictive glance, but Acteon, having dropped his bow in surprise, is not looking at the goddess, whom he has not yet seen, but at the alarmed nymph behind the rusticated pillar. Even the handmaid drying Diana's feet is not yet aware of his presence, though the nymph squatting next to her surveys him with dispassionate criticism. Trouble clearly lies ahead. The carved plinth rocks like an overloaded raft and there is a threatening air to the shifting shadows, presaging a storm and a rising wind.

Venus and Adonis, 1554
Oil on canvas, 186 x 207 cm
Madrid, Museo Nacional del Prado

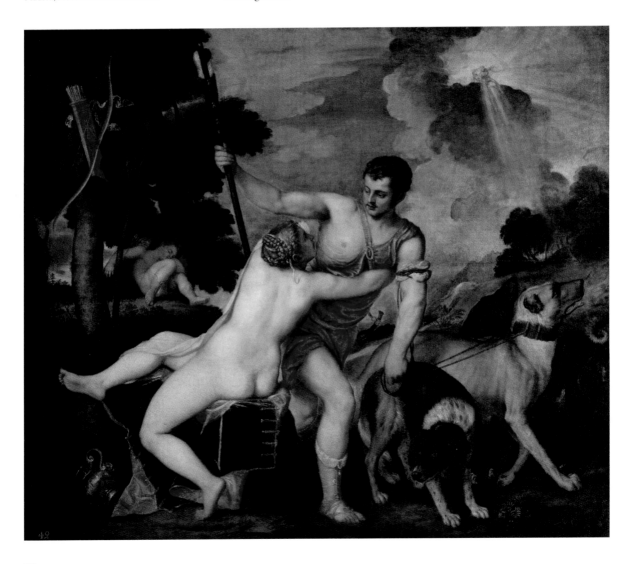

The cold morning light of *Diana and Acteon* gives way in *Diana and Callisto* to the warmer glow of late afternoon. The nymph Callisto, whom Jupiter has seduced and left pregnant by assuming Diana's form, is brought before her mistress. The chaste goddess, supported by an attendant who leans forward with prurient curiosity, imperiously condemns the unfortunate young woman. Diana's face is in shadow, an ominous sign with Titian in so prominent a figure and prophetic of Callisto's punishment, which is to be banished by her mistress, changed into a bear by Juno and nearly killed by her own son, though Jupiter eventually came to her rescue by placing her among the stars. Her companions relish her discomfiture: the standing nymph to the left exposes Callisto's distended belly with the promptitude of a school mistress unmasking a cheating pupil, while her seated counterpart looks back up at the goddess with malicious satisfaction. At one level - and perhaps the level most appreciated by Philip II – these pictures offer a mythological foretaste of Ingres' *Bain Turque*. But they also carry

Diana and Acteon, 1556–1559
Oil on canvas, 184.5 x 202.2 cm
Edinburgh, Duke of Sutherland Collection, on
loan to the National Gallery of Scotland

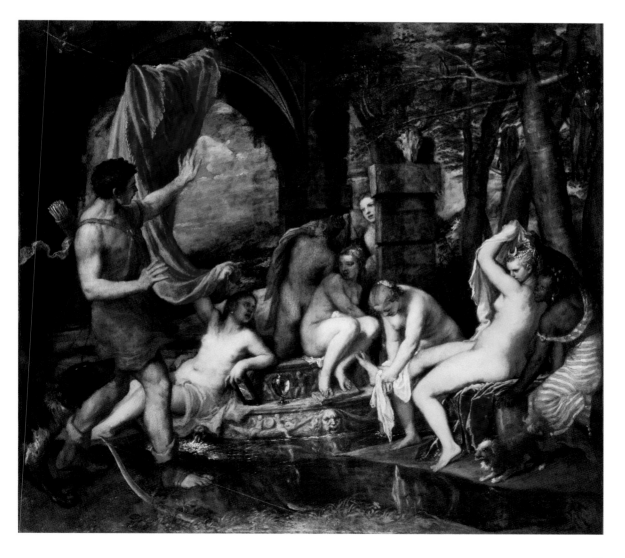

a deeper message, that clashes with the powers-that-be are fraught with risk and that even honest mistakes attract exemplary punishment. The arbitrary cruelty of the Olympians evidently fascinated Titian, whose friendships with men of power would also have acquainted him with the realpolitik of high levels of authority. Whether such undertones were apparent to the patron, however, is uncertain.

The best preserved of the *poesie* and the finest Titian in the New World is *The Rape of Europa* (p. 77), sent to Spain in 1562. Europa's Hellenistic sprawl remains classical, but her fleshy limbs anticipate Rubens (who copied the painting). Watteau and the Rococo also beckon in the sinuous curve of her rose pink cloak. Her raised arm casts a shadow of alarm across her face, and her parted thighs blatantly foretell her imminent fate at the hands of her abductor. Jupiter's disguise may have helped tempt Europa into his clutches, but she is clearly not

Diana and Callisto, 1556–1559
Oil on canvas, 187 x 204.5 cm
Edinburgh, Duke of Sutherland Collection, on loan to the National Gallery of Scotland

The pendants *Diana and Acteon* and *Diana and Callisto* were formerly in the collection of Philippe Egalité, Duc d'Orleans. After the French Revolution they were purchased by the immensely wealthy Duke of Bridgewater and still belong to his descendants.

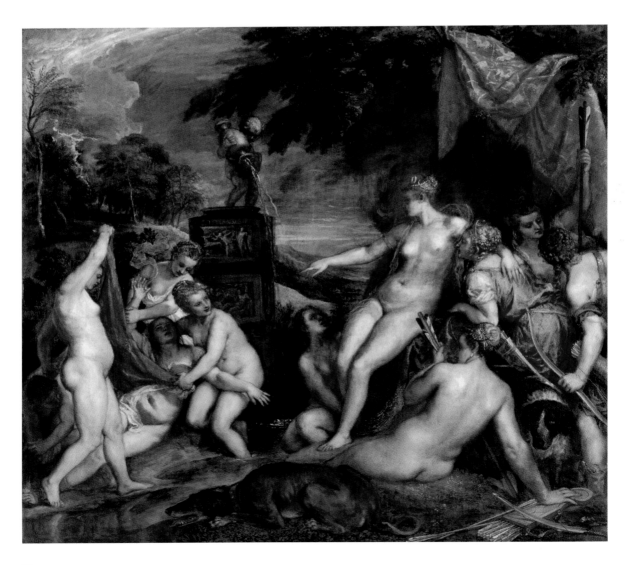

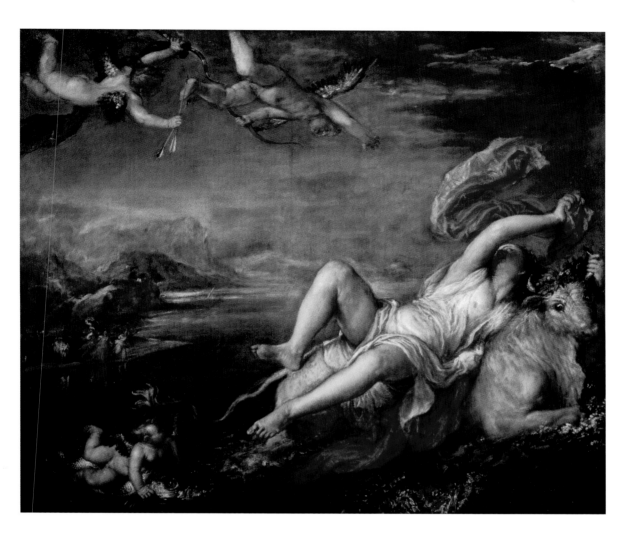

used to riding bulls. The disguised god is far from being in control of the situation, and the bull's staring eyes look close to panic. Titian originally painted its tail looped back toward Europa, but then extended it out over the putto on the dolphin, tickling him up in a desperate plea for help. Despite the shock of her abduction, Jupiter's attractions may not be entirely unwelcome: Europa's expression combines fear and desire, as if encouraging the putti in pursuit to let loose their arrows of love. At the end of the day she appears less a desolate victim of rape than part of the endless cycle of change, fertilized by visceral passions and forces of nature both human and divine. Titian here reconciles classicism and romanticism, the ideal and the real, the tragic and the comic in a rich pictorial language whose resonance would be felt right up to the late 19th century.

The Rape of Europa, 1559–1562
Oil on canvas, 185 x 205 cm
Boston (MA), Isabella Stuart Gardner Museum

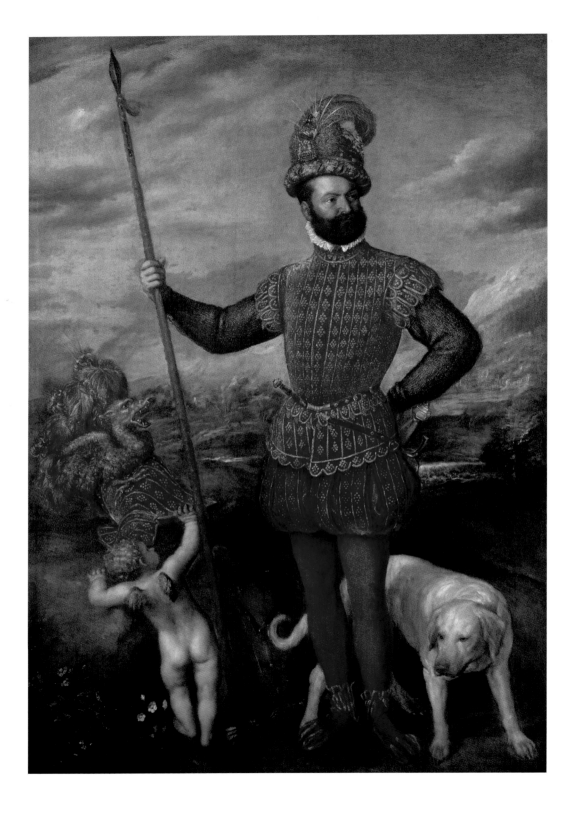

"Chromatic Alchemy": The Late Works

Titian's bold and broadly painted late works are periodically compared with the later Rembrandt, and their critical fortune over time has been likewise uneven. Titian's late style was far from being widely understood even in his own day, when some critics considered it evidence of faltering powers and failing eyesight. It is only quite recently, subsequent even to the admission of Impressionism into the canon of established art, that their elemental shorthand has come to be fully accepted as the culmination of Titian's artistic achievement. The pithiest summary of Titian's late style is offered by the Lombard artist and art theoretician Giovanni Lomazzo, writing in the late 16th century, who speaks of Titian's "chromatic alchemy". The alchemist mysteriously forges gold out of base metal just as Titian, in a way that is equally hard to analyze, forges masterpieces out of the raw material of paint. More recently we have Roberto Longhi's "magic Impressionism", with which he refers to broken colors and brushwork that are no longer descriptive in themselves, but coalesce to convey meaning at a distance.

We are fortunate to have a vivid account of Titian's later working process from his pupil, Palma Giovane, as quoted by the 17th-century biographer, Mario Boschini. Titian would sketch in the groundwork with a great mass of boldly applied color, after which he would turn his canvases to the wall, often for several months. Eventually he would re-examine them "with the utmost rigor, as if they were his mortal enemies, to see if he could find any faults" and in the last stages of completion, "he painted more with his fingers than his brush." Not all of Titian's late works are as broadly handled as this implies. To meet the enormous demand for his work, Titian needed to employ many assistants, and in his later period only the most important clients could expect to receive works that were entirely from his own hand. This situation continued after his death when many works were left unfinished in the studio. Some have come down to us in that state today (p. 79), but others seem to have been worked up by others to make them more saleable. Different again is the case of the *Venus with a Mirror* (p. 91). Titian completed it but retained it in his studio until his death, possibly as a model for replicas.

The epic power of Titian's late works accorded with the demands of the Counter-Reformation for religious imagery commanding strong emotional involvement, a subject-matter that would have appealed to Spanish royal taste just as much as Titian's more sensuous mythological subjects. Thus the two

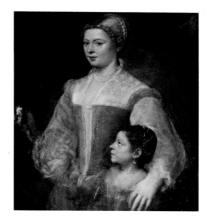

Portrait of a Lady and her Daughter,
late 1540s to 1560s
Oil on canvas, 88.3 x 80.7 cm
Private collection

After Titian's death, this portrait was radically over-painted, turning the figures into Tobias and the Archangel Raphael. Recent removal of the over-paint has restored the canvas to the unfinished state in which Titian left it. The psychological intensity of the child heralds the work of Van Dyck in the next century.

Portrait of a Man in Military Costume,
early 1550s
Oil on canvas, 229 x 155.5 cm
Kassel, Staatliche Museen Kassel,
Gemäldegalerie Alte Meister

Edinburgh *poesie* that Titian dispatched to Philip in 1559 were accompanied by *The Entombment* (p. 80). The broader and more open brushwork that Titian was now developing here serves to trap the light and add a torrid and glittering intensity to the colors. The dead weight of Christ's body is accentuated by collapsing the rhythm of the figures towards the left, resisted only by the bearded figure of Nicodemus. The latter has Titian's features, as if the artist wanted to allocate to himself a responsible role in the burial process, just as Michelangelo had portrayed himself as Nicodemus in his unfinished *Pietà* of c. 1550 in Florence Cathedral. The Gospels describe Christ's tomb as being excavated out of rock, but in Titian's interpretation it takes the form of a classical sarcophagus decorated with the Christian themes of Cain and Abel and the Sacrifice of Isaac – Old Testament events considered to prefigure the Crucifixion and Resurrection. The corner of the sarcophagus projects into the very front of the picture plane in a cutting analogy of the disciples' grief.

The previous year, 1558, marked the installation of Titian's *Crucifixion* (p. 82) in the Church of San Domenico in Ancona. The painting had been commissioned by the Cornovi family, who had recently moved to Ancona from Venice.

The Annunciation, c. 1564/66
Oil on canvas, 403 x 235 cm
Venice, San Salvatore

The composition derives from a lost *Annunciation* that Titian painted in 1537 for the nuns of Santa Maria degli Angeli in Murano. The nuns rejected it as too expensive, so Titian promptly presented it to Charles V hoping to encourage further commissions.

BELOW:
The Entombment, 1559
Oil on canvas, 137 x 175 cm
Madrid, Museo Nacional del Prado

The motif of the Virgin holding the limp arm of Christ is inspired by Raphael's *Entombment* in the Villa Borghese and perhaps also by Aretino's *Humanity of Christ*.

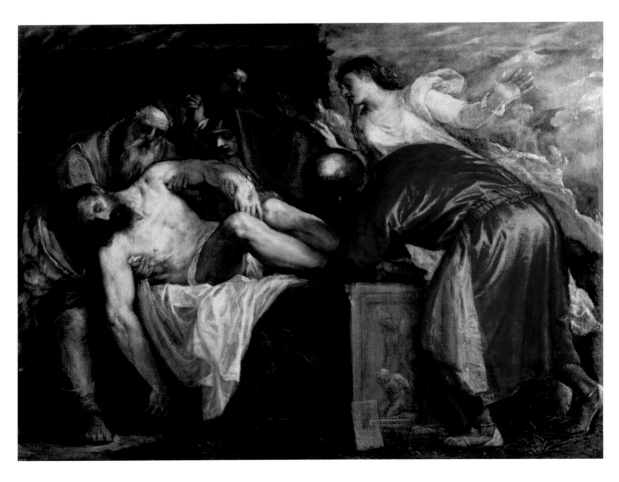

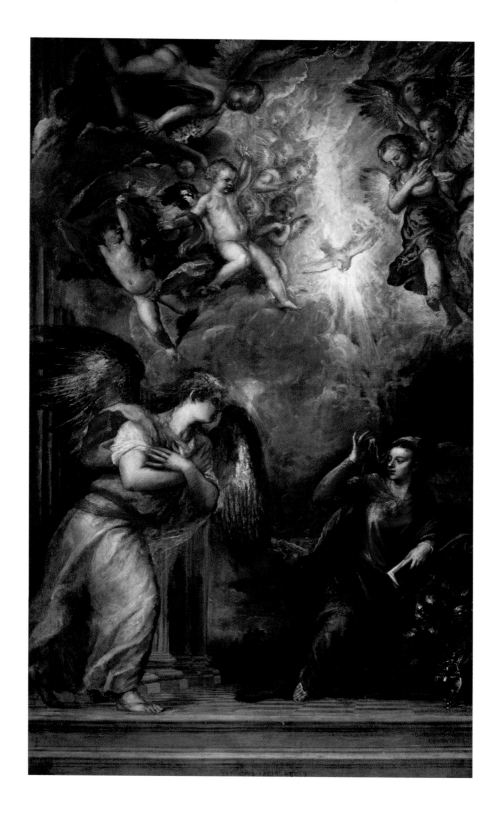

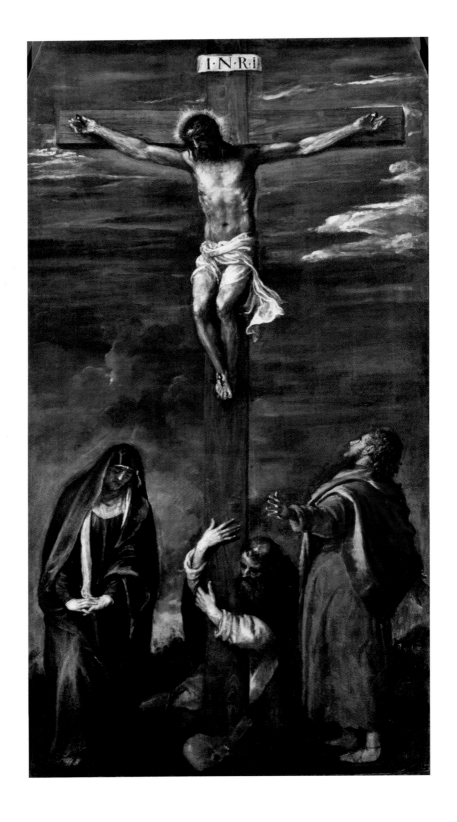

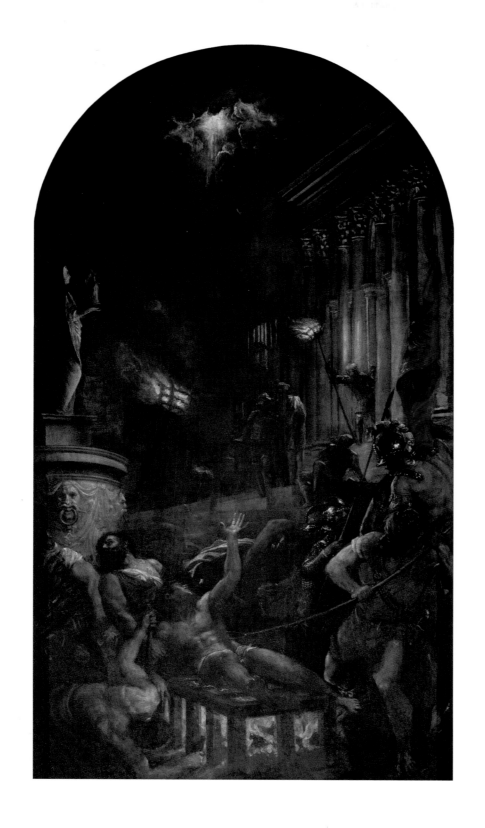

PAGE 82:
The Crucifixion with the Virgin and SS John and Dominic, 1558
Oil on canvas, 375 x 197 cm
Ancona, Museo Civico, formerly in the Church of San Domenico

PAGE 83:
The Martyrdom of St Lawrence, 1558/59
Oil on canvas, 493 x 277 cm
Venice, Chiesa dei Gesuiti

According to Panofsky, the painting was inspired by the *Passion of St Lawrence* by the early Christian writer Prudentius, in which the saint's martyrdom symbolized the transition from paganism to Christianity.

Venus Blindfolding Cupid, c. 1560–1565
Oil on canvas, 118 x 185 cm
Rome, Galleria Borghese

The stark placement of the three mourners in the immediate foreground, inviting us to share their suffering, makes this one of the first masterpieces of Counter-Reformation art, where narrative clarity and emotional empathy were denoted as artistic priorities. Under the fitful gleams of Armageddon, we are already in the world of Tintoretto's San Rocco *Crucifixion*, painted in the mid-1560s. The Virgin and saints are arranged in a crescent, like the head of an anchor, at the base of the cross. On the left, the Virgin sways in solitary grief, while in the center St Dominic, with exaggeratedly long fingers, feverishly clutches the base of the cross to draw strength. Christ, more fully illuminated than the others, is already beyond their reach, an effect Titian achieves by making him a little smaller than the rest and so creating a feeling of distance and separation. The blood which is pointedly depicted coursing along the sinews of his arms and down his side to soak into the loincloth also conforms to the taste and tenets of the Counter-Reformation.

The Martyrdom of St Lawrence (p. 83), painted for the Chiesa dei Gesuiti in Venice, was probably completed in the same year as the *Crucifixion* but had been ten years in the making. As we have seen, Titian in his later years seemed preoccupied with the fate of those who defied authority, and the present work is about a desperate attempt – in this case by the forces of paganism – to suppress dissent in secret and at night away from the public gaze. The sweep of the figures from upper right to lower left reinforces the curve of the trident thrust into St Lawrence's ribs and the martyr's face is brutalized by pain even as he recognizes his salvation, a ray of light punched through the cloud cover.

A key religious painting of the next decade, *The Annunciation* (p. 81) in the Church of San Salvatore near the Rialto, was painted for the same Cornovi

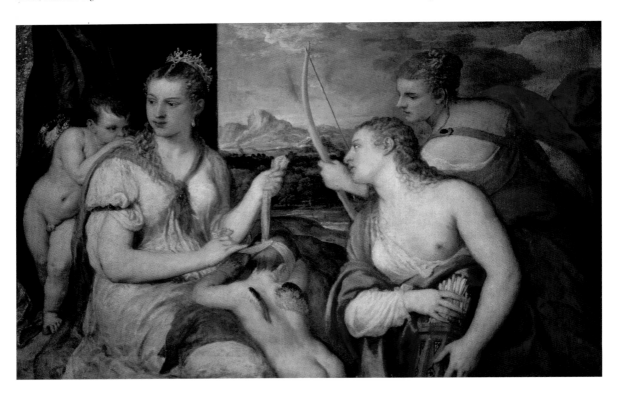

family who commissioned the Ancona *Crucifixion*. The *Annunciation* is one of Titian's boldest and most freely painted late works. The traditionally acquiescent pose of the Virgin, with arms crossed as she receives the message, has been transferred to the angel since Titian has here chosen to depict the moment just after the actual Annunciation itself. The Virgin, having lifted her veil to receive the Word, remains in suspended animation as she absorbs it, while the angel stands in awestruck reverence at the implications of the news just imparted and at the mystery of the incarnation. There is a materiality about this painting that belies its otherworldliness. Gabriel's wings are the reverse of feathery and have the surface density of beaten brass, yet the viewer is seduced into believing that the wings of angels could exist in no other form. The upper part of the composition brings to mind Lomazzo's concept of "chromatic alchemy": just as base metal is turned to gold, so the base material of pigment is here fired up in the crucible of Titian's late manner, until it explodes in a fissile shaft of light, splitting the heavenly throng apart and thunderously acknowledging the golden age of the new dispensation initiated by Christ's incarnation in the Virgin's womb.

Venus Blindfolding Cupid (p. 84) is among the best known of Titian's later mythologies and revisits a similar half-length composition of 30 years earlier, the *Allegory of Marriage* today in the Louvre, Paris. In his Neoplatonic interpretation of *Venus Blindfolding Cupid*, Erwin Panofsky identifies the sighted cupid with Anteros, the love that raises the soul to contemplate the divine, and the blindfolded cupid with Eros, associated with earthly love. Venus, in the act of blindfolding the cupid in her lap, turns in response to his counterpart, who whispers behind his fist at her shoulder, possibly warning against the perils of love that is blind. She sparkles mischievously as if in sympathy with the bad cupid though obliged to listen to the advice of the good one. The blind cupid is unarmed, but acolytes offer Venus the weapons of love. The female figure in the background gravely proffers a bow while her companion, about to pull the arrows from their sheath, looks anxiously at the goddess as if to say that in view of the advice Venus is apparently being given, perhaps they had better remain where they are! Even if the meaning is still not entirely clear, *Venus Blindfolding Cupid* encapsulates the simplicity and humor of which Titian had been a master since his Padua frescoes of 1511 (pp. 12, 13).

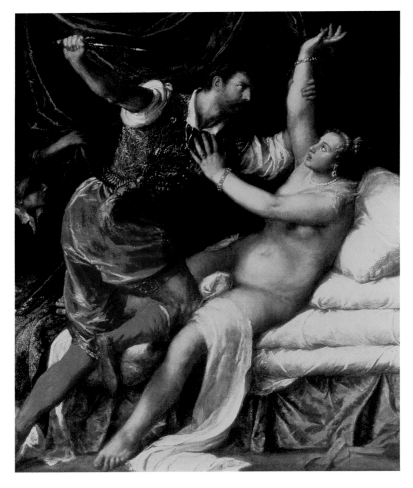

Tarquin and Lucretia, 1569–1571
Oil on canvas, 188.9 x 145 cm
Cambridge, The Fitzwilliam Museum

Titian described this painting as "an invention of painting of much greater labor and ingenuity than perhaps I have produced for many years."

PAGE 88:
Crowning with Thorns, c. 1572–1576
Oil on canvas, 280 x 181 cm
Munich, Bayerische Staatsgemäldesammlungen, Alte Pinakothek

Allegory of Prudence, mid-1560s
Oil on canvas, 75.5 x 68.4 cm
London, The National Gallery

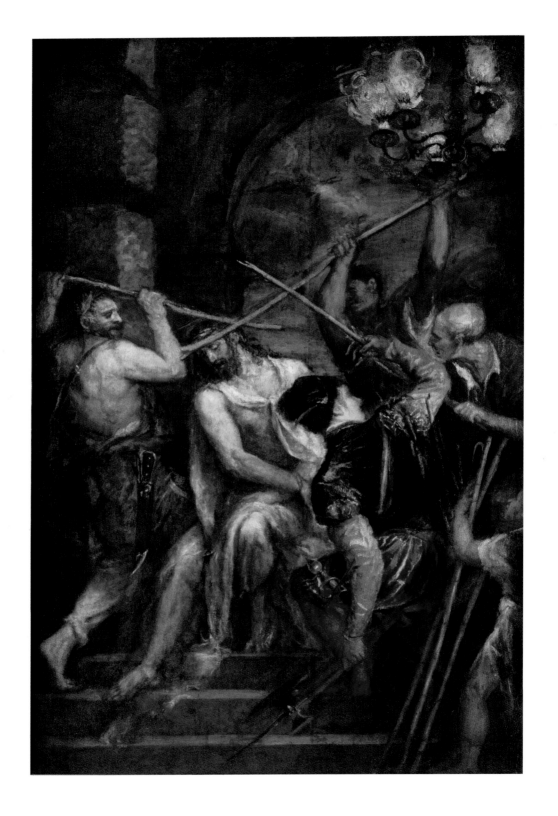

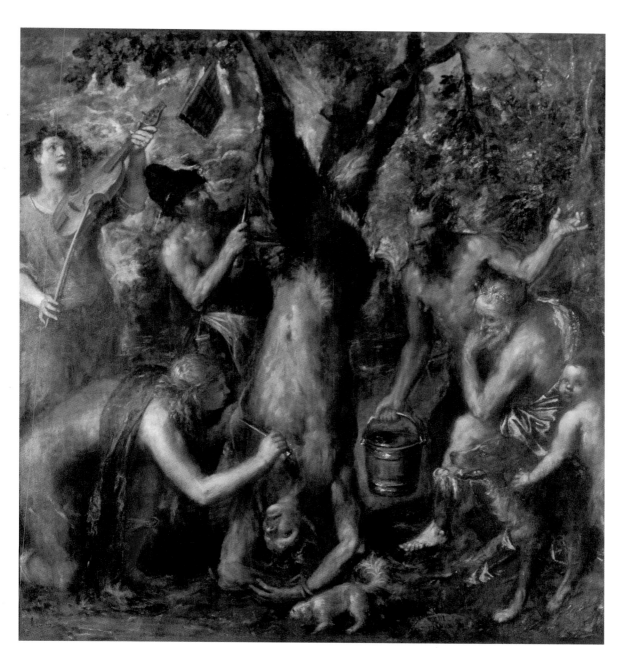

The Flaying of Marsyas, c. 1570–1576
Oil on canvas, 212 x 207 cm
Kromeríz, Archiepiscopal chateau

This painting has been interpreted as the triumph
of the divine art of Apollo and the stringed instrument
over the rustic flute-playing satyr, or alternatively
as representative of the spiritual cleansing brought
about by the shedding of the Dionysian self.

In the latter part of his career Titian continued to give as much care to portraits, though painting fewer. The most flamboyant is the *Portrait of a Man in Military Costume* (p. 78) dateable to the early 1550s. Surprisingly in so swagger an image, the sitter has escaped identification. His costume is an odd mixture of the civil and the military, and he is portrayed so theatrically that it is hard to take him seriously. Titian only adopted the full-length format for clients of the highest rank and surprisingly in so swagger an image the sitter has escaped identification. His outfit also needs to be better understood since it seems half way between a military and a hunting costume.

In the next decade Titian began to record himself and his family. His daughter Lavinia, who was born after 1530, has been associated with the *Girl with a Fan* (p. 85, right) as well as with the *Young Woman with a Dish of Fruit* (p. 85, left), and both portraits are characterized by a pride and affection that suggests a strong personal bond with the artist. The Prado *Self-Portrait* (p. 92) of c. 1560 shows Titian as withdrawn and distant in near profile, in contrast to an earlier *Self-Portrait* (p. 2) in Berlin, where he appears without the tools of his trade but as if staring critically at an unseen canvas as described by Palma Giovane.

In the *Allegory of Prudence* (p. 87) Titian has portrayed himself, his son Orazio and possibly his nephew Marco as the Three Ages of Man: from left to right, old age, maturity and youth. The inscription and the animal heads indicate that this is an allegory of Time governed by Prudence. The painting may be some kind of artistic testament, expressing the hope that the painter's kin may benefit from his legacy. Titian's face is in shadow as he unsparingly reviews the past while Orazio stands between darkness and light, the emerging present. His gleaming eyes betray few illusions about life's unpredictability, in anticipation of which he looks left, towards the light representing the future. Meanwhile, the more evenly lit Marco stoically awaits what is to come.

In the last decade of his life Titian revisited two subjects he had treated earlier, the Crowning with Thorns and the Martyrdom of St Lawrence. The second *Crowning with Thorns* (p. 88) in Munich may be a canvas mentioned by both Ridolfi and Boschini as left unfinished in the studio at his death. If the earlier Louvre version (p. 54) is a heroic struggle in the spirit of the Laocoön, the mood in the Munich painting is resigned and ritualistic and the setting nocturnal, illuminated by a chandelier whose torches bloom like exotic flowers in the dark.

Two very different works, *Tarquin and Lucretia* (p. 86) and *The Flaying of Marsyas* (p. 89), develop the theme of martyrdom in a secular context. In *Tarquin and Lucretia* the blurring of the contours of Tarquin's right foot below his dropped stocking kinetically conveys the impetuosity of his onslaught, and the mixture of lust and anger in the white of the king's eye has an unquenchable animalism. However, despite the violence, a certain attraction on the part of the victim for her seducer perhaps lurks under the surface, unlike in a smaller, sketchier version in Vienna.

The Flaying of Marsyas, until recently little known, is now everybody's favorite late Titian and demonstrates how in his final years he pushed hard against the boundaries of the High Renaissance classicism that – for all his acknowledgement of Tusco-Roman Mannerism – had always been his most sustaining force. Its clinical cruelty strikes home after the horrors of 20th-century strife, and technically it is as freely painted as a Delacroix, its descriptive language owing as much to the juxtaposition of color as to the modeling of form. Marsyas, a flute-playing satyr from Phrygia, challenged Apollo to a musical contest, lost, and was skinned alive for his presumption. Titian shows him strung up like a carcass as

Venus with a Mirror, c. 1560
Oil on canvas, 106.8 x 136 cm
Washington (DC), National Gallery of Art

Though almost in profile, Venus shows her awareness of the spectator in the teasing fragment of her reflection in the mirror where she appears looking directly out. X-rays show that her cloak is a reworking of that worn by a male sitter in a double portrait underneath which Titian partially erased and painted over.

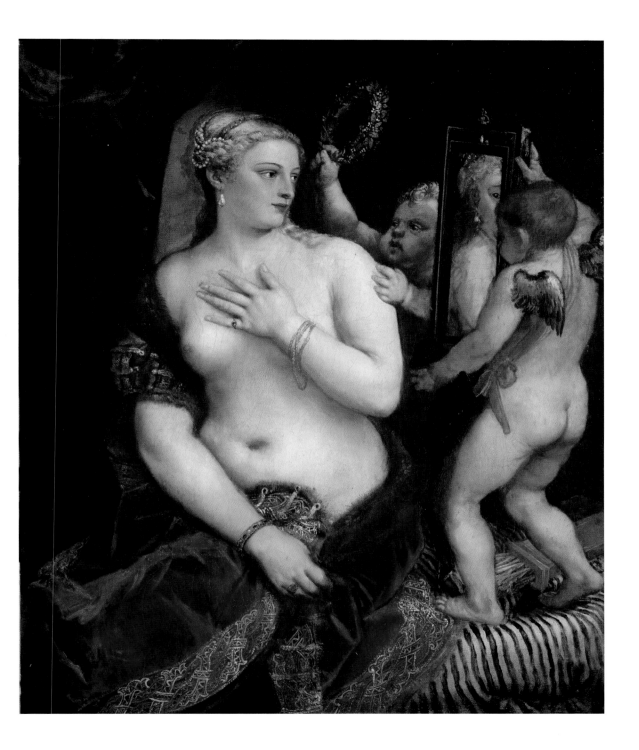

Self-Portrait, c. 1560
Oil on canvas, 86 x 65 cm
Madrid, Museo Nacional del Prado

This portrait was once owned by Rubens. In contrast to the earlier Berlin *Self-Portrait* (p. 2), the artist now holds a paintbrush.

his tormentors ply their knives. To his right sits Midas, king of the Phrygians, who had run into similar problems with Apollo. Appointed to judge a contest between the god and Pan, he awarded Pan the victory and was punished by the loser with ass's ears. Midas' features are Titian's, as he sits meditating on what has happened to Marsyas, possibly relieved to have got off so lightly. Behind a satyr with a bucket pulls up in horror and in front a small dog licks up the blood before it soaks into the ground. Marsyas' expression is a mixture of deadly fear and incomprehension, and the brushwork, which becomes frenzied in the background, evokes the screams we cannot hear.

It has been suggested that the *Marsyas* may refer to the loss of Famagosta in Cyprus to the Turks in 1571 and the flaying of the Venetian commander Marcantonio Bragadin. On the other hand, it fits in just as well with other late Titians that warn against the dangers of challenging divine authority. Even Apollo, wielding his violin, seems in trance-like thrall to the sacred duty of those with power to extract the most brutal retribution in order to retain it, in the face of which art itself, in the person of Midas/Titian, must remain a passive and powerless spectator.

Titian's final gift to the world is the *Pietà* (p. 93), perhaps originally painted for the Cappella del Cristo in the Frari church in return for a concession that he be buried there. According to an inscription at the lower edge it was finished by his pupil Palma Giovane, but the latter's intervention is mostly confined to the torch-bearing putto. A clue to the painting's intent is provided by the little ex-voto in the bottom right-hand corner, which shows the artist and his son Orazio kneeling before a smaller Pietà to invoke protection against the plague. The disease, rife in Venice in the mid 1570s, was to kill Orazio but not Titian, who seems to have died of a fever. The ex-voto subject is taken up again in the main composition, where a penitent figure bearing Titian's features, possibly intended to represent St Jerome or Job, kneels before a larger pietà inspired by Michelangelo's great precedent in St Peter's. Mary Magdalene sways and trumpets her grief and as a reformed sinner, dramatizes the expiatory message of the picture as a whole. Further references to Christ's sacrifice and the redemption of man are contained in the statues: Moses to the left represents the Old Testament and prefigures Christ the Redeemer, while the Hellespont Sibyl opposite was held to have prophesied the Crucifixion and Resurrection. Another resurrection symbol is the pelican succoring her young in the mosaic of the apse. Against this desperate parade of redemptive iconography, the mood oscillates between hope and fear. The mosaic may be a comforting reminder of St Mark's, but the aedicule guarded on both sides by snarling lions looms like the gates of hell in a Rodin. Rusticated architecture, as in the first *Crowning of Thorns* (p. 54) or the *Ecce Homo* (pp. 56–57), is once again used as a metaphor for oppression. In his final meditations on the afterlife, Titian faced a problem especially daunting for the creative artist – the prospect of a future state that cannot be seen or even imagined. Such terrible uncertainties are evident in the flesh of Christ, which vaporizes like a shifting pattern of cloud, and in the way the triangle of figures is set down so abruptly in front of the niche. The juxtaposition is harsh and grating, but just holds together as the artist ferociously deploys the power of art to do battle with the fear of the unknown. For Titian, death, like his unfinished canvases, is here a mortal foe, the last enemy.

Pietà, mid-1570s
Oil on canvas, 378 x 347 cm
Venice, Galleria dell'Accademia

This painting was much admired by the
Marquis of Ayamonte, the Spanish governor
of Milan, who had a deeper appreciation
than many of Titian's late style.

Titian c. 1490–1576
Chronology

c. 1490 Titian is born in Pieve di Cadore in the Dolomites, the eldest of four children.

c. 1500/1502 Arrives in Venice, where thanks to the mediation of Sebastiano Zuccato he begins his apprenticeship in Gentile Bellini's workshop. A short time later, he transfers to the Workshop of Gentile's brother, Giovanni.

c. 1509 Works with Giorgione on frescoes for the façade of the Fondaco dei Tedeschi. Venice is defeated by the League of Cambrai. Outbreak of plague.

1510 Death of Giorgione.

1511 Works on the frescoes of the *Miracles of St Anthony of Padua* (pp. 12, 13) in the Scuola del Santo in Padua. Sebastiano del Piombo leaves Venice for Rome.

1513 Declines invitation from Pietro Bembo to go to Rome. Applies for a government sinecure, the equivalent to official recognition as painter to the Republic, and is awarded a commission to paint a battle scene for the Doge's Palace.

1516 Paints *The Tribute Money* (p. 24) for Alfonso d'Este.

Giovanni Britto
after Titian
Self-portrait, c. 1550
Woodcut, 41.5 x 32.5 cm
London, The British Museum

1517 Receives his sinecure following the death of his teacher Giovanni Bellini.

1518 Completes the *Assumption of the Virgin* (p. 30) for the high altar of the church of Santa Maria Gloriosa dei Frari in Venice.

1519 Starts work on the *Pesaro Madonna* (p. 38).

1520 Completes *The Worship of Venus* (p. 35), the first of a mythological cycle of three *Bacchanals* for Alfonso d'Este.

1520–1524 Paints *Bacchus and Ariadne* (p. 37) and *The Adrians* (p. 36).

1526 Unveiling of the *Pesaro Madonna*. Starts work on the *St Peter Martyr* (p. 31) altarpiece for SS Giovanni e Paolo, destroyed by fire in the 19th century. Regarded as a masterpiece, its dynamic power anticipated the Baroque.

1527 Pietro Aretino and Jacopo Sansovino, the latter a refugee from the Sack of Rome by imperial troops, arrive in Venice.

1529 Begins working for Federico Gonzaga, Duke of Mantua and nephew of Alfonso d'Este, who arranges for him to meet the Hapsburg emperor Charles V.

1531 Moves to new quarters in the Biri Grande, henceforth his lifelong residence.

1532 Titian is mentioned in the latest edition of Ariosto's *Orlando Furioso*.

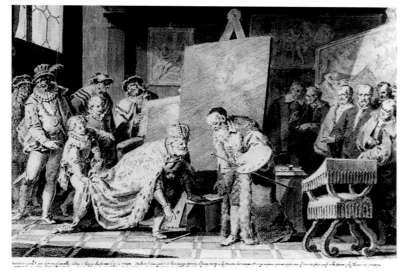

Pietro Antonio Novelli
The Emperor Charles V stoops to pick up Titian's paintbrush
Pen, ink and wash, 35.8 x 48.7 cm
Private collection

BELOW:
Titian's tomb in S. Maria Gloriosa dei Frari by pupils of Canova, 19th century

1533 Meets with Charles V in Bologna and after painting his portrait is created Count Palatine and Knight of the Golden Spur.

1538 _Venus of Urbino_ (pp. 46–47) acquired by Guidobaldo della Rovere. Titian finally completes the battle scene for the Doge's Palace commissioned in 1513 (and destroyed by fire in 1577). Declines invitation to the Spanish court. Finishes _The Presentation of the Virgin_ (begun in 1534; p. 51).

1541 The biographer Giorgio Vasari visits Venice. Titian is mentioned in the first edition of his _Lives of the Artists_ published in 1550.

1542 Enters into contact with the Farnese, the family of Pope Paul III. Completes the _Crowning with Thorns_ (p. 54).

1543 Completes _Ecce Homo_ (pp. 56–57). Portrait of _Pope Paul III_ (p. 67, below).

1545 Visits Rome and meets Sebastiano del Piombo and Michelangelo.

Inspects antiquities in the Vatican with Vasari.

1546 Returns to Venice.

1548 Summoned to Augsburg by Charles V. Tintoretto unveils his _Miracle of the Slave_ (p. 71).

1550 Summoned to Augsburg by Prince Philip. Starts withdrawing from Venetian market to work for the Hapsburgs.

1553 First of the _poesie_, a series of mythologies, sent to Philip.

1554 Delivers _La Gloria_ (p. 70) to Charles V.

1556 Death of Aretino. Titian awards first prize to Veronese in an assessment of paintings for the St Mark's Library.

1566 Titian becomes a member of the Florentine Accademia del Disegno and obtains control of prints made after his paintings from the Council of Ten.

1568 Second edition of Vasari's _Lives of the Artists_, in which Titian is treated

more fully than in the earlier edition of 1550.

mid-1570s Paints the _Pietà_ (p. 93). The work was probably intended for his own tomb.

1576 Plague in Venice. On 27 August Titian dies of a fever.

Photo credits

The publishers wish to thank the museums, private collections, archives, galleries and photographers who granted permission to reproduce works and gave support in the making of the book. In addition to the collections and museums named in the picture captions, we wish to credit the following:

© AKG, Berlin: p. 95 below; © Archiepiscopal chateau, Kromeríz (Milan Posselt): p. 89; © Artothek, Weilheim: pp. 14 (Alinari 2005), 16, 22, 46–47 (Paolo Tosi), 50 top (Imagno), 50 below (Paolo Tosi), 56–57, 88 (Blauel/Gnamm);

© Bildarchiv Preußischer Kulturbesitz, Berlin: back cover, pp. 2, 59, 85 left; © The Bridgeman Art Library, London: pp. 77, 91; © Christie's Images Limited: p. 79; © Koninklijk Museum voor Schone Kunsten, Antwerp: p. 27; © Kunsthistorisches Museum, Vienna: p. 25; © Museo Nacional del Prado, Madrid: pp. 8, 19, 35, 36, 40, 45, 52, 68, 69, 70, 72 top, 72 below, 73 left, 73 right, 74, 80, 92; © National Gallery, London: pp. 6, 9 below, 17 below, 37, 58, 87; National Gallery of Art, Washington, Image © 2005 Board of Trustees: front cover, pp. 63, 86; © National Gallery

of Scotland, Edinburgh: pp. 28–29, 75, 76; © Photo RMN – Droits réservés: pp. 10–11, 21, 41; © Photo RMN – Thierry Le Mage: p. 39; © Photo RMN – René-Gabriel Ojéda: pp. 42, 54, 60; © Photo SCALA, Florence: pp. 12, 13, 15, 18, 30, 32, 33, 34, 38, 43, 53, 81, 82, 83; © Photo SCALA, Florence – courtesy of the Ministero Beni e Attività Culturali: pp. 7, 9 top, 17 top, 20, 23, 44 left, 44 right, 49, 51, 55, 61, 62, 64–65, 66, 67 top, 67 below, 71, 84, 93; © Staatliche Kunstsammlungen Dresden: pp. 24, 48, 85 right; © Staatliche Museen Kassel: p. 78.